Interpreting
The Figure
In Watercolor

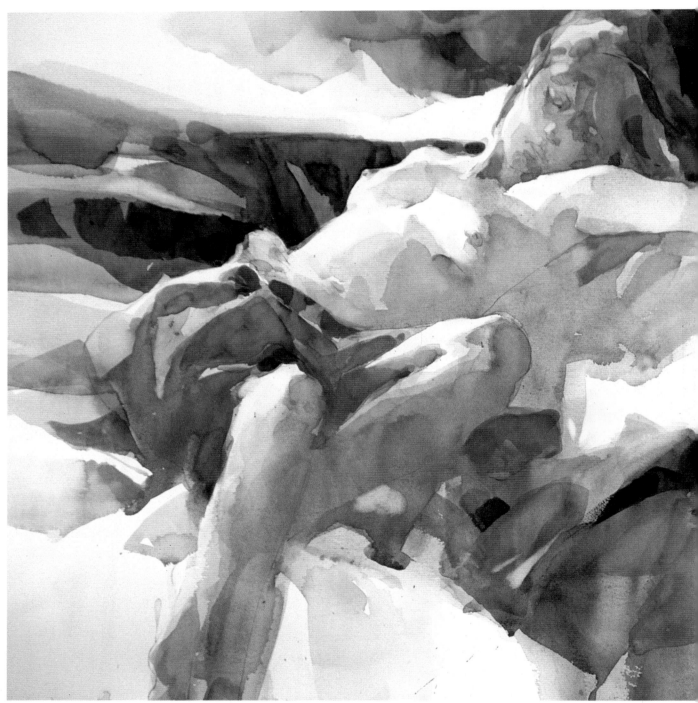

QUIET SLUMBER, watercolor on Arches 140 lb. cold-press paper, 22" x 30" (55.9 x 76.2 cm).

INTERPRETING THE FIGURE IN WATERCOLOR

Don Andrews

WATSON-GUPTILL PUBLICATIONS / NEW YORK

Copyright © 1988 by Watson-Guptill Publications

First published 1988 in the United States and Canada by Watson-Guptill
Publications, a division of Billboard Publications, Inc., 1515 Broadway,
New York, N.Y. 10036.

Library of Congress Cataloging-in-Publication Data

Andrews, Don, 1951–
 Interpreting the figure in watercolor.

 Includes index.
 1. Human figure in art. 2. Watercolor painting—
Technique. I. Title.
ND2190.A54 1988 751.42'242 88-17154
ISBN 0-8230-2548-9

Distributed in the United Kingdom by Phaidon Press Ltd., Littlegate
House, St. Ebbe's St., Oxford

Manufactured in Japan

First Printing, 1988

1 2 3 4 5 6 7 8 9 / 93 92 91 90 89 88

TO MY BEST FRIEND, WIFE, AND FAVORITE MODEL—LINDA

I first want to thank God for giving me whatever talents I en-joy. To my mother, who on a teacher's salary, found money for art books, materials, and art school. To my first art teacher, Mrs. Jane Shaw, whose love of art and teaching has been passed on to me. Special thanks to Robert E. Wood, my good friend and mentor, whose teaching and painting concepts can be found throughout this text.

To Bonnie Silverstein, who first suggested I write this book, thanks for all your help and encouragement. I'd also like to express my gratitude to both Candace Raney for her expertise in editing this book, and to the art director, Areta Buk.

Thanks to Bruce and Teresa, and Frankie and Lynn for always be-ing there.

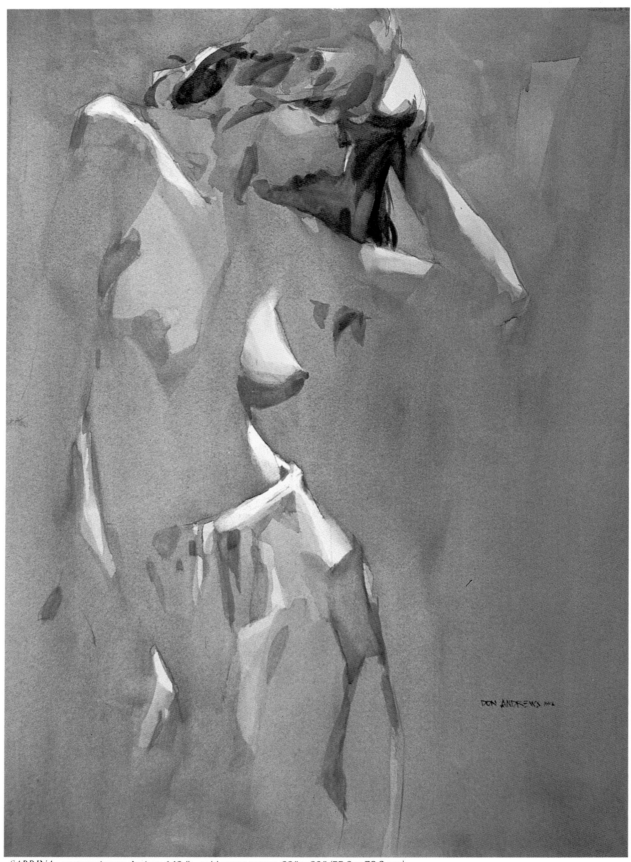

SABRINA, watercolor on Arches 140 lb. cold-press paper, 22" x 30" (55.9 x 76.2 cm).

CONTENTS

INTRODUCTION

Our first challenge as aspiring artists is to draw or paint the world around us we see it. Soon, however, we begin to realize a much more personal and valid goal. We begin to look within ourselves to find the answers to what art can be, rather than depending on nature to supply these answers for us. The moment we look beyond the subject matter to find the answers to what painting can be, we take our first steps as true artists. This book is written for the painter who is ready to take those steps.

Throughout the book we will be working with the formidable subject matter of the human figure, but it will be the personal interpretation of this subject matter that is the true goal.

This is not a "how to" book, though I will be constantly trying to explain my ideas, actions, and reasons in each of my exercises. "How to" implies that I *know* how to; and if there is one thing I have learned about painting, it's that we never learn "how to." Indeed, it seems the answer that works wonderfully in one painting will be totally wrong in the next. Knowing "how to" is in direct conflict with creativity. The lessons that follow will be suggestions of places to look as you search for your own identity as an artist. Some lessons will be in conflict with others, for this is the nature of art. There are no absolutes, no right answers.

Some of the material that follows will be my own discovery, but most of the concepts are borrowed from painters with whom I have studied in one form or another: many workshops with Robert E. Wood, the books of Rex Brandt, Charles Reid, Stan Smith; a slide presentation of the paintings of Serge Hollerbach; the painting philosophy of Robert Henri and Millard Sheets, the paintings of Gauguin and other post-impressionists. As students of art, we are lucky to have so many wonderful teachers and so very much to learn. Yet we know our education will always be incomplete. I love to hear these masters confess their insecurities. Their attitude is one of searching rather than knowing; it is this attitude that has made them what they are. My friend Al Brouillette tells a story of Cézanne, who when told of his impending death, remarked, "Damn, just when I was catching on!"

Look forward to the fight, enjoy the uncertainty that comes with creativity, expect to struggle. Painting should always be a struggle. The day we learn how to paint is the day we stop being artists.

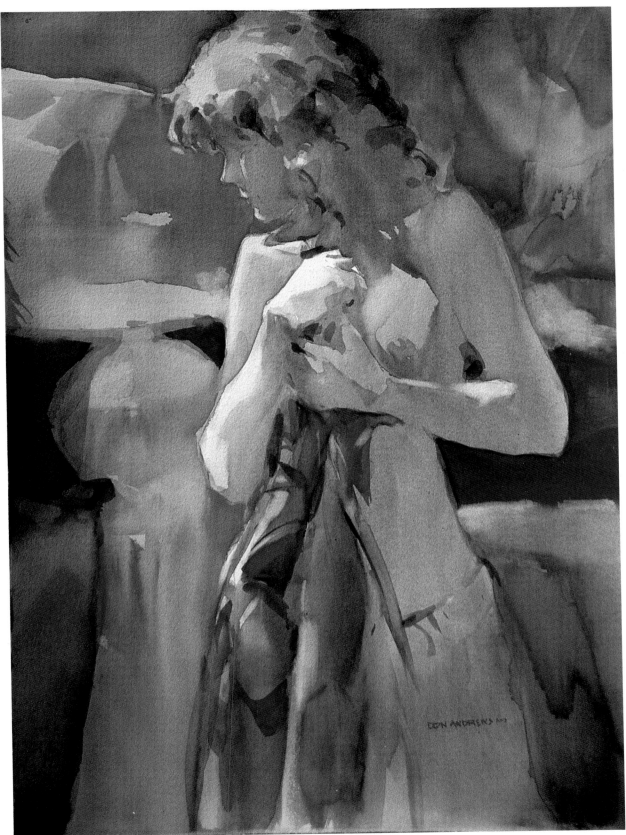

POLLY, watercolor on Arches 140 lb. cold-press paper, 22" x 30" (55.9 x 76.2 cm).

DRAWING

Nothing seems more curious to me than to see a person look up close at a watercolor and criticize, "You can see the drawing!" The first step, or foundation, of most watercolors is, of course, solid drawing. It is the purest and most basic art form. If I had to critique your work or my own, whether you are just starting out or have painted for many years, I would say you probably don't draw enough. We never outgrow our need for it. Always keep a sketchbook close by and make quick sketches, enjoy, and don't worry too much about the outcome.

I begin all my figure classes by warming up with a series of quick gesture drawings of about two minutes each. These quick action poses don't allow time to worry about detail or a great amount of accuracy. The goal is to warm up, enjoy the lines, and produce a gestural interpretation of the figure. I am always amazed at how exciting these abbreviated drawings are. Even the beginners seem to have little problem with proportions or anatomy.

This is an example of a typical page in one of my sketchbooks; this one measures 14" x 17" (35.6 x 43.2 cm). If I turn the book on its side, the drawing area becomes 28" x 17" (71.1 x 43.2 cm), which allows me more room to explore the figure. Even so, in this particular pose, the model is cut off at the knee. Though there isn't a right or wrong size when drawing a figure, I feel I can make better use of the page (or, as in this case, pages) in most poses if I allow the figure to take up a good portion of the space. If the figure runs off the page, I allow it to do so. I don't feel the need to include the entire figure in every sketch.

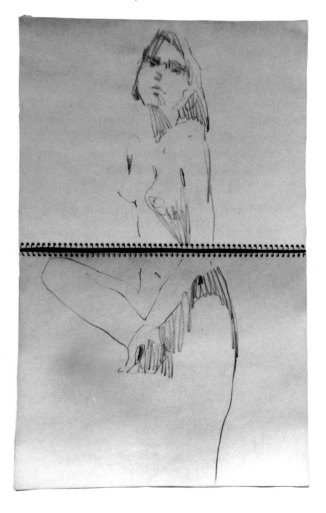

DRAWING MATERIALS

It is advisable to experiment with a variety of materials when exploring the figure in gesture drawing. However, I have found that some materials lend themselves to the large, abbreviated figure statement more than others.

I enjoy working in class on large newsprint pads with compressed-charcoal sticks. The compressed-charcoal stick is about the same size as an ordinary stick of charcoal but is a bit heavier and has a much smoother consistency. It will easily go from the finest razor-edge line to a dense black mass if you add a little pressure to the stroke. These sticks are a little more expensive than the regular stick of charcoal, but luckily, they last longer as well. I also have an assortment of Conté crayons, and here again, I reach for the softer ones.

Grumbacher makes a 4B graphite pencil that I have just discovered and find myself using regularly. Because it is solid graphite, this pencil has a little more weight to it and feels good in my hand.

I enjoy drawing in sketchbooks. I always try to use one of the larger sizes—11″ x 14″ (27.9 x 35.5 cm) or larger. When drawing in a sketchbook, I generally prefer a graphite pencil to a felt-tip pen because of the flexibility of the pencil's line quality from light to dark. However, the pencil will smear where the pen won't. I'm not bothered by this, though, as the work in my sketchbook is mainly for my immediate benefit and is rarely shown.

Watercolor paper makes an excellent drawing surface for quick gesture drawings. I usually prefer the Arches 140 lb. paper or smoother Fabriano papers for drawing, and I generally use a medium 2B pencil or a 4B graphite pencil because they allow me the variety of both a fine line and a bold, dark line. The only drawback to using the watercolor paper is, of course, the price, so I save my watercolor paintings that didn't turn out and use the reverse sides to sketch upon.

Sometimes I add paint to a drawing on watercolor paper, and the drawing becomes the foundation for a watercolor. Most of the time, however, I leave these gesture drawings as they are and enjoy them for their own merits. Drawing is a wonderful and complete art form in itself. Please don't overlook this vital medium.

Compressed charcoal, with its heavier consistency, really allows the artist to blast the darks. This gesture statement is more an expression of my reaction to the materials and pose than an attempt to explain the subject.

Soft Conté crayon on newsprint produces a nice line quality. By turning the crayon on its side, I can get a solid, powerful mass. Here, I captured the figure with a quick, gestural line, then turned the crayon on its side and worked back into the drawing to state the linkage of shadow patterns.

GESTURE DRAWING

Aside from warming us up for the oncoming painting session, doing a series of quick gesture drawings of the figure on a regular basis pays other dividends as well.

Gesture drawings aid your growth as an artist by forcing you to eliminate and balance detail. They force you to search for the essential shapes needed to explain the pose. You then begin to rearrange your thinking as to the importance of detail versus mass and note how effectively the large simplified mass areas of your drawing can balance the one or two areas of detail that you, the artist, decide belong in the drawing. Because you are giving yourself a minute or two to suggest the impression of the figure, you are forced to look at the overall shapes that explain the bulk of the figure. You thus record the essence of what you see.

For this drawing, I worked with a compressed charcoal stick on a newsprint pad. The gesture drawing session demands that the artist state the essentials of a pose rather than labor over details. I could have spent an hour on this drawing, trying to visually explain the complexities of the folds and creases that actually existed in the drapery, but I'd rather explore possible ways to link the figure and the drapery together with the use of light and shadow.

I drew this on a newsprint pad with a compressed charcoal stick. I am often a little tight at the beginning of the gesture drawing session—the blood's not flowing, so to speak—so I usually give myself the simple goal of loosening up the first few two-minute gesture poses. Rather than doing careful drawings, I really try to make broad strokes and flowing lines that just hint at the figure, and if I make a mess, so be it. I find that after doing a few of these "wake-up" drawings, I begin making the figure a bit more structurally sound, but the drawings still have the looseness and excitement that I enjoy. Later in the day, I'll get out the watercolor paper and begin a figure painting by constructing the image of the figure with a pencil drawing. Hopefully, the drawing on my watercolor paper will benefit from the loosening of both attitude and line that is the goal in this early warm-up gesture session.

LEARNING TO SEE

Another reward of the gesture drawing session is that through these quick, interpretational accounts of the human form, you teach yourself to "see." Though it might sound strange to think that an artist must be taught to "see," I have found that with a regular routine of putting down a variety of quick, simple drawings of the figure, you gain a more honest understanding of how the figure is constructed and how it moves and changes. The head isn't always balanced on top of the shoulders, and the legs seldom stand equally below the hips. By "seeing" and understanding more completely the unique arrangements of shapes each different pose presents, you are able to give a more personal and exciting interpretation of the pose.

Nothing impresses me more than a solid, powerful drawing without tricks or gimmicks. There seems to be a purity, an economy and directness, that captures an emotion or a moment in a way that nothing else can. In this pose, the model seemed at first glance to be standing completely balanced, yet by moving to one side, I began to see small variations that make the pose interesting. For instance, the model's head is bowed a bit and turned slightly to her left, and her left shoulder is raised to meet it. These gentle variations seem to accent the model's quiet mood.

LOOKING AT THE
OVERALL POSE

Most of us are able to draw the proportions of the figure fairly well when we direct our attention to the overall pose. It is only when we concentrate on one area or part at a time that our anatomy problems surface. When we do this, we generally draw the individual parts well but make errors like having the head too small for the torso or making the arms too long. To avoid these common errors, look at the overall pose and sketch in some general proportions before getting into the specific details.

When the model strikes a new pose, take a few seconds to get a visual understanding of the unique shape arrangements the figure is making before you begin to draw. Rather than looking at the separate parts of the figure, try to get the overall pose in mind. Concentrate on the torso to tell the story of the pose (A), *then* notice how the extremities (head, arms, and legs) are related to the torso (B).

Once you have taken a few seconds to look at the overall pose and get some understanding of how the general structure of the figure is displayed, you can begin to gesturally put down a quick impression on your drawing paper.

From the very start of the sketch, you should be concentrating more on your drawing and less on the model. Many times I find that students tend to construct the drawing, spending too much time looking at the model and too little time actually looking at the drawing in front of them. They concentrate so hard on getting the parts explained correctly that they overlook gesturalizing the overall pose. Again, when this happens, students usually draw specific parts well but they don't fit together as a whole.

To avoid this problem, make a mental note to practice looking more at your drawing and less at the model during the gesture session. When you concentrate on the gesture drawing on the paper before you and just occasionally glance up at the model, you will begin to abbreviate more and make the proportions of the figure fit together more believably. You will begin to make the figure drawing make sense on the page. Remember, the model will be changing poses quickly and you will have only your drawings as a record. I think you'll agree that it is more rewarding to have an exciting interpretation of the overall pose than a tedious explanation of eyelashes and fingernails.

A

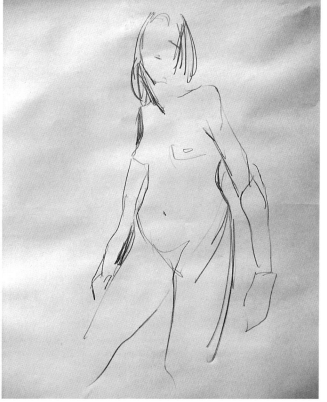

B

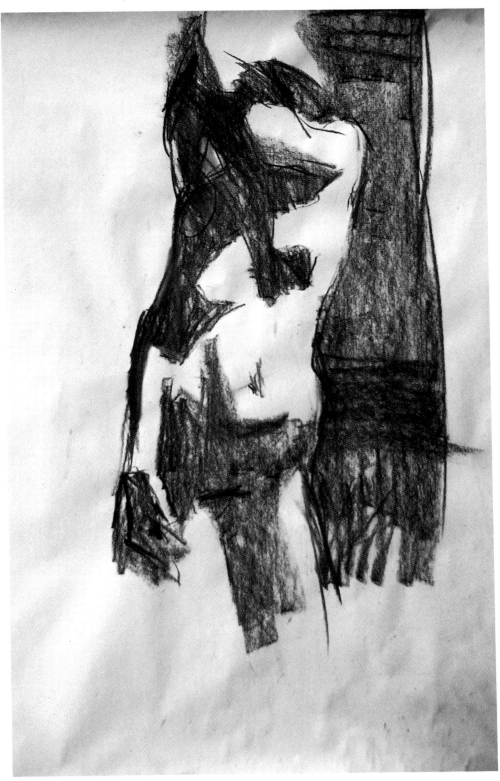

This drawing was done with a compressed charcoal stick on a newsprint pad. When the model struck this pose, I was impressed with the wonderful patterns that were created by the light and shadow as they moved across the planes of the figure. I decide not to explain the features but to make only one distinction: "What is in light and what is in shadow?" In effect, I'm drawing not the figure but the light or shadow pattern that sits on top of the figure. To add to the impression of light, I created a simple background shape on the right to sandwich the light between the two dark patterns. Squint your eyes and look at this drawing not as a statement about the figure so much as a statement about light.

PROPORTIONS

When I have trouble with proportions, I usually find I am concentrating on one area of the figure, explaining a part of the figure rather than stepping back and looking at the subject as a whole. But you can avoid this problem by following these suggestions.

First, lay down some large gestural lines that hint at the structure of the figure (A) before you begin refining or finishing an area or specific part of the figure (B). Start thinking like a sculptor as he begins to model a figure from a mound of clay. First, he shapes the bulk or mass of the figure into general proportions, then he gradually refines and adjusts the shapes until finally, at the finish of the work, he introduces the detail. That is the way we, too, should construct the figure, working from the general to the specific.

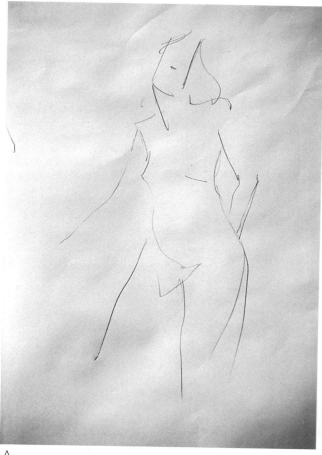

A

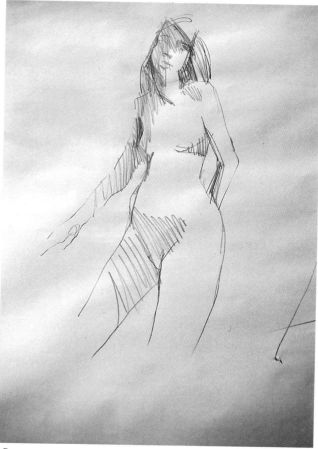

B

ANATOMY

At the beginning of my first year at art school, figure class was a source of total frustration for me. One of my first assignments was to copy the figure in an anatomy book and render every muscle and bone group and memorize its name, placement, and function. Though I was able to grind out these renderings with some success, when it came time for the model to pose, I was just as confused as ever. I could name and recognize the parts and pieces, but I wasn't able to translate this knowledge into acceptable figure drawings. However, after a few months of daily drawing in figure class, I slowly forgot about the anatomical explanations of the figure and began to draw the overall shapes as I saw them. For instance, though the figure is technically seven heads high, I seldom saw a model standing at attention (A). As I began to forget what I knew about muscles and bone structure and began to draw what I saw, things began to improve (B).

It has been suggested to me that even though I might not consciously think about the anatomical structuring of the muscles and bones, those early anatomical lessons have helped me better understand the shapes I see and therefore draw. This might well be so. Certainly the more I know about the figure, the better I am able to draw it.

My suggestion is to learn all you can about the anatomy of the figure and then put aside what you know and draw what you see.

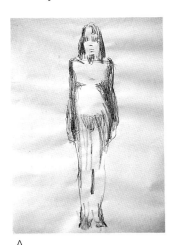

A

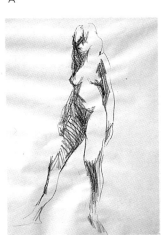

B

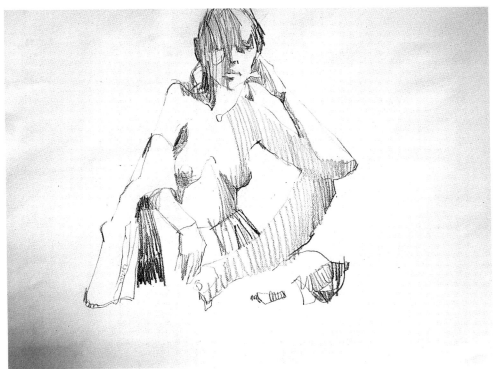

Why take time to draw? The more I look at, draw, and paint the figure, the more comfortable I feel with my understanding of the figure's basic structure, or anatomy. The more I understand about the structure, the more I am able to direct my attention to other valid concerns of painting rather than just explaining the figure's anatomical construction. We painters are able to begin our creative exploration or look beyond the figure only after we know it well.

MAKE THE DRAWING
FIT THE PAGE

When exploring the figure with charcoal or pencil, I believe it's good practice to do these drawings on about the same size paper that the later watercolor will be painted on and to allow the figure to fill the page.

Many students create wonderful small figure studies during the drawing session and are frustrated when these small impressions don't hold their original strength when enlarged on the watercolor paper. Also, by getting used to working large, we overcome our fear of drawing on the watercolor paper. Why is it that we are able to do such exciting, loose drawings in a two-minute gesture session, yet when we get out the good watercolor paper to begin a finished paint-

ing, we tighten up and lose the good qualities we enjoyed in the earlier drawing session?

Once I thought I could hide my inadequacies by making small figure drawings; I assumed that small drawings were not as difficult to do as larger ones. However, I have discovered that if I enlarge the drawing it is actually easier to handle. I have more room to explore and thereby gain a broader understanding of the structure.

Of course, there is no right or wrong size, but during the drawing session, try working large to gain a better understanding of how the figure is constructed and how it can best be displayed on the page.

These two drawings are of the same pose drawn on the same size paper. Though neither example should be considered right or wrong, the large drawing on the left allows me much more room to work into and explore the subject.

THE SKETCHBOOK

Drawing in a sketchbook should be a time to search and explore, to enjoy yourself and not feel the pressure of performance. Looking through my sketchbook, I find a slightly different degree of success and understanding of the figure displayed on each page. A good drawing will be followed by a bad one, or a pose will be successful on one page but an identical pose will look terrible on the next. The success of a sketchbook should be measured by the wider understanding you gain of the figure rather than the outcome of a sketch on a particular page.

The sketchbook is a good place to begin to work out ideas for patterns of light and dark that you will translate into a more decisive watercolor statement. In this drawing, I tried to create a union between the features on the left side of the face, hair, shoulder, arm, breast, drapery, and stomach by pulling these separate features together with a large shadow pattern. If this union of parts is visually pleasing in the sketch, there is a good chance it will also work well in the later watercolor painting.

I drew this with a 4B graphite pencil in my 14" x 17" (35.6 x 43.2 cm) sketchbook. I consider my sketchbook drawing to be a time for exploration. I try to gain new understanding of the figure rather than just show what I already know. If we technically analyze this drawing, there are many inaccuracies. The bottom leg is too long, and so is the forearm across the torso. I could go back and get out the eraser and make corrections, but in this particular drawing, I was more interested in finding a new arrangement of shapes on the page rather than explaining anatomy.

PAINTING MATERIALS

Rather than spending a great deal of time on this topic, I'd like to just mention the materials I generally use. Since my painting equipment is fairly common, you are probably already familiar with most of it, and you may own several watercolor books that explore this subject in detail. Rather than take my word as to what materials are best, I advise you to experiment with them yourself and find out what works best for you. My feeling about watercolor materials is that you should buy the highest quality you can possibly afford. The masters may be able to produce a beautiful work of art with a beat-up brush and three dabs of student-grade paint, but I need all the help I can get. I'm also reminded of a girl in my class whose clean new brushes were stored in the bottom of her paintbox while she struggled with old ragged ones until she got "good enough." As with anything else, the quality of the materials used will usually reflect the quality of the finished product.

PAPER. I have tried a variety of quality papers over the years and have settled almost exclusively on the Arches 140 lb. cold-press paper. This paper doesn't deliver the striking razor-edge brushstrokes that many hot-press papers produce, nor does it equal the rough-surface papers in showing off a glowing wet-into-wet granulated wash. However, I find that the Arches 140 lb. cold-press paper flexible enough to deliver both these qualities of sharp edges and pigment granulation to a satisfying degree. Since I like to have the option of both these paint qualities available to me when I paint, I enjoy this "middle of the road" paper.

Rather than stretching paper by wetting it and stapling it to a paint board, I use binder clamps on the four corners of my paper to hold it to the board. Next, I wet the paper to expand it. Once it has relaxed, I reclamp it to the board and dry it with a hair dryer. The paper will be resoaked many times in the course of a painting, and when the paper relaxes again, I can easily take the clamp off, pull the paper tight, and reclamp it so it remains flat.

BRUSHES. There are many brands of brushes around, and no doubt you already own several types. I use the synthetic or white sable brushes exclusively, because I find they hold their shape and snap well and

handle just like the sable brushes. The only difference is, of course, the price. It could be argued that sable brushes will last a lifetime, whereas the synthetic sable brushes will not, but I'm always afraid I'll misplace or damage my brushes somewhere along the way, and I'd much rather replace the synthetic brushes than their expensive counterparts.

I don't feel the need for a great number of brushes, as I find most of them do about the same thing. There certainly isn't one right size or number to get, but my feeling is this: You should own a small, a medium and a large round brush, and a small, a medium, and a large flat brush. I find these six brushes suit my needs comfortably, and if I had a no. 28 round, and you already owned a no. 26 round, I doubt either of us could tell the difference if we switched.

PAINT. There are, to my knowledge, three brands of professional quality watercolor paints available: Winsor & Newton, Grumbacher's Finest, and Holbein. I've used all three of these brands extensively and find them all to be acceptable, although shades of some colors vary, depending on the brand. One shade is not necessarily better than another, just different. There is however, some variation in price; the Winsor & Newton and Holbein are imported and cost a little more.

There are a great many choices of colors available, and I force myself to try out a new tube almost every time I make a paint order. I'll list the colors I am using on my palette now, but no doubt the list will change in the future. However, I do seem to have old standby colors that remain on my palette year after year. This list is a simple and basic one; these should not be considered to be the right or the only colors to have:

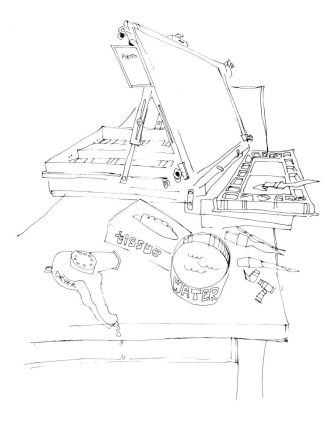

Raw sienna	Opera
Burnt sienna	Cobalt violet
Cadmium yellow	Turquoise
Lemon yellow	Sap green
Naples yellow	Cerulean blue
Aureolin yellow	Manganese blue
Cadmium red	Ultramarine blue
Alizarin crimson	Peacock blue
Permanent magenta	Prussian blue
Vermilion	Ivory black

STUDIO EQUIPMENT. I'm basically a studio painter, and I have a long rectangular table on which I set my French box easel to paint. The studio is well lit, and I have a mirror on the wall just opposite my easel so I can quickly get a look at the painting in reverse during the course of its development. I find the reversed image in the mirror to be a great help in discovering organizational possibilities, and I recommend you try this procedure if you're not doing so already. Because my worktable is long, it allows room for other basic equipment, such as my palette, water container, hair dryer, and tissue box, all of which have their appointed spaces.

There always seem to be new gadgets and painting equipment coming on the market that are designed to make life easier for the artist in one way or another. I'm sure some of these new painting aids are most beneficial, but I try to limit my gear to these basic items I have discussed. If you see some new painting tool in a supply book or store, however, and you feel it will help you, by all means give it a try.

SIMPLICITY

Early in our watercolor painting experience, we discover the power of simplifying the subject rather than reporting every detail. By interpreting nature in terms of simple shapes, we can bring more order and boldness to our work.

When we go outdoors to paint the barns, flowers, and boats, we expect to take liberties with these subjects, simplifying and readjusting nature to fit our needs as artists. Somehow, though, when the subject in nature is the human form, all too often we put these good interpretational ideas of simplicity and reorganization away in our paintboxes and instead copy what we see. We would never attempt to paint a tree by explaining every leaf; yet in figure painting we sometimes try to mirror the image of the model in every detail. When we do this, we begin breaking the figure up into many pieces rather than simplifying these parts to bring more order to our work.

Throughout this book, I will be putting forth the concept that successful figure painting is more than a visual explanation of anatomical parts. I believe the

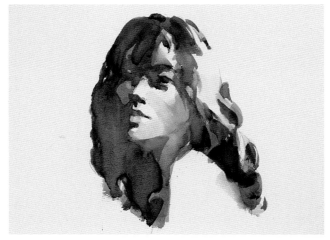

When painting the features and activity that occur on the face of the model, we can quickly become overwhelmed with detail. Here, I tried to report the structure of the model's face as it actually appeared. Rather than making artistic choices as to what would be shown off and what would be pushed back, I simply reported the facts as I saw them. There are many changes of shapes, form, and texture that occur in the small area of the face; the details of tiny brushstrokes can be found everywhere. No detail is more or less important than its neighbor, and each becomes a competitor for the viewer's attention.

This describes more the direction I would like to take you in this book. This painting departs from reality for its own sake. I have described the model's face with not so much an explanation of reality as an interpretation of reality. There is interest and detail, but it is balanced with simple, noncompetitive areas. I made the features on the right side of the model's face more demanding of the viewer's attention by pushing back or eliminating the competitive detail on the left side of the model's face. Rather than painting strands of hair on the left side of the face, I developed a symbol that describes the mass of the hair and invited the viewer to interpret this symbol as hair.

whole equals more than the sum of the parts. Certainly there is nothing wrong with reporting detail, giving information with tiny brushstrokes, but I believe we have gone down the "detail road" long enough. We have experienced painting the little, the in-focus, gradually filling the painting with equally important characters that compete for our attention. I think we can benefit from exploring the figure in other directions as well.

A central theme throughout this book will be learning to pull the separate pieces of the figure together to create a unified balance of interest rather than explaining the anatomical parts of the figure. Naturally, some detailed information is necessary to the success of our work, but we will be continually searching for ways to simplify and better organize the available information in order to create a more balanced result.

First, consider that the human form is filled with detailed information from head to toe. Every square inch of the figure has some change in shape or form. If we report this information exactly as we see it, we will be scattering information throughout the painting, making all areas of the figure equal in finish and interest. When we paint with this "report-the-subject" attitude, often what is missing is the overall organization of the subject. Rather than reporting nature as we see it, I believe it is our job as artists to play down (simplify) some areas of interest in order to enhance or show off others that we feel are special and would like the viewer to more readily notice. The artist organizes nature rather than reports it.

If you were to ask what I've been doing today, and I were to reply, "Well, I got up, took a shower, brushed my teeth, had eggs and toast for breakfast, read the paper . . ." pretty soon I'd be telling you more than your really wanted to know. In reporting every detail of the subject in our painting, we lose the mystery that makes viewing the painting exciting. By leaving a little unexplained, we invite the viewer to look closer, to discover, and to interpret. I believe more paintings fail from telling too much about the subject than from not telling enough.

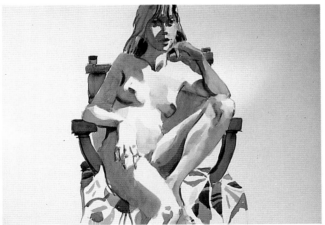

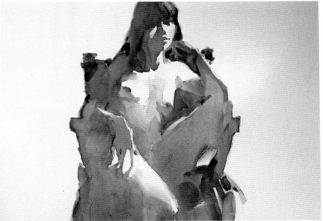

Now let's apply this same concept of simplicity to the entire figure. In this illustration, I again developed a painting that shows the figure as it actually existed in nature. Notice that although I might have explained the parts of the painting well enough, they have no relationship to one another. The hair is completely different from the face, the chair is unrelated to the model, the fabric draped over the seat of the chair has nothing in common with the figure or the chair. The painting becomes nothing more than a visual inventory of the parts it explains.

In this example, I allowed myself to become selective as to what would be shown off, and just as importantly, what would be eliminated. Notice how much more interesting the light on the face and torso becomes when I remove the competition. I have developed a feeling of unity by allowing the figure to be constructed with large passages of shadow and mass rather than with many tiny brushstrokes that explain the parts and pieces. By building a common bond of color and allowing the color of the figure to flow into the chair and the fabric draped across the chair, I have created a linkage between separate characters.

SIMPLIFYING NATURE

On my first trip to California, I was impressed with the character of the weather-beaten pines that guard the rocky California coast. Let's look at how a watercolorist might simplify this subject in a painting to create a bolder interpretation of nature rather than merely reporting the facts.

In the first example (A), I have attempted to report the subject essentially the same way a camera might. Little has been left to the imagination. Every branch and twig is in focus; every leaf is equally rendered. Detail is well explained, but every inch seems to be equally reported. I have left little for the viewer to discover. Detail has become common; I have dictated what a tree is, inch by inch, much like a picture puzzle.

Now let's look at how we might attempt to simplify this same subject. In the first phase (B), I begin the painting in terms of an overall gesture of the subject, a boiled-down, simplified statement of what the character of the subject seems to be. I realize there is more to come, that this isn't the time for the finish but the time to create a powerful foundation on which the finish is then built. When painting in this fashion, I am always a little surprised at how close to the finish this gestural beginning can be. I quickly realize that not much explanation needs to be added in order for the subject to come to life.

In the second phase (C), I work back into the subject with some medium-size shapes. Some information begins to appear; hints of limbs, branches, and clusters of leaves take form. I begin to introduce interest, but much is still left unsaid. The areas of information that are coming into focus are balanced by areas that are kept simple or unexplained.

In the final stage of the painting (D), the detail is added. The painting is complete. This doesn't mean that interest is scattered throughout the subject; instead, interest is balanced and placed not so much as the subject matter dictates but as I feel the need. The artist must choose where the detail goes, and just as importantly, where the detail is left out. Simplicity involves not only the elimination of detail but the reorganization of detail as well.

A central problem we all face in the early phases of our figure-painting experience is that we often attempt to construct a figure painting in a different manner than we attempt construction of a landscape, seascape, or still life. We must learn to think as much like a watercolorist in figure class as we do in landscape class. Simplification, organization, interpretation, and shape-making are the language of the watercolorist—of all watercolorists, regardless of their subject matter. Our task is to organize, not report.

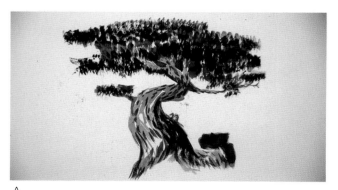

A

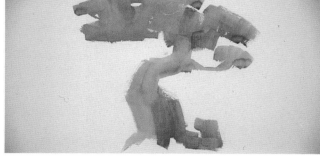

B

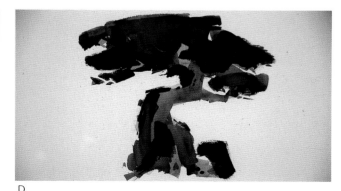

C

D

ENHANCING DETAIL
THROUGH SIMPLICITY

Simplifying subject matter involves us in a personal realm of making choices: deciding what will be accentuated as well as what will be pushed back or eliminated. When we simplify by eliminating detail, we automatically enhance the detail that remains. In other words, the less competition an element of detail in a painting has, the more it will catch our eye or be brought to our attention. Therefore, we enhance at the same time as subdue.

In the first painting (A), I have tried to explain the detail of light as it actually appears on the model's face. Notice how common the light is as it jumps from one area to the next. The light is non-special, busy, and uninteresting.

In the next three examples (B, C, D), instead of reporting reality, I have intentionally enhanced the light on the model's face by eliminating a good bit of the light. Notice the importance of the remaining light. Be aware of the power an artist has at his or her fingertips. In the three remaining examples, I have chosen to enhance different anatomical areas by eliminating the competitive lights. We simplify by eliminating detail, but we also enhance the few details (in this case, the lights) that are left.

A

B

C

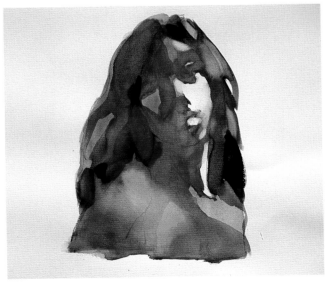

D

Painting is decision-making. It is our job as artists to decide what is important in a painting and what is not. In the photo I took of my wife Linda looking at herself in the mirror, there were many small and interesting lights and shadows that described her face, hands, and front. However, there was also a great deal of activity occurring just as dramatically on the shadow side of her hair, shoulder, back, and hip. I chose to enhance the activity of her face, hands, and arm, so I decided my best course of action would be to simplify areas or develop noncompetitive masses to surround the detail I wanted to capture. Thus, the back side of the hair becomes a large, simple shape that melts down into Linda's back and sneaks out into the background. The background is kept as a simple form where it meets the interest on the face and hands, and I allow it to become a little more interesting on the right side of the painting since it is placed against the simple shapes on the back side of the figure. In effect, the left side of the figure is interesting, so the left side of the background is kept simple. The right side of the figure is simple, so the right side of the background can be more interesting.

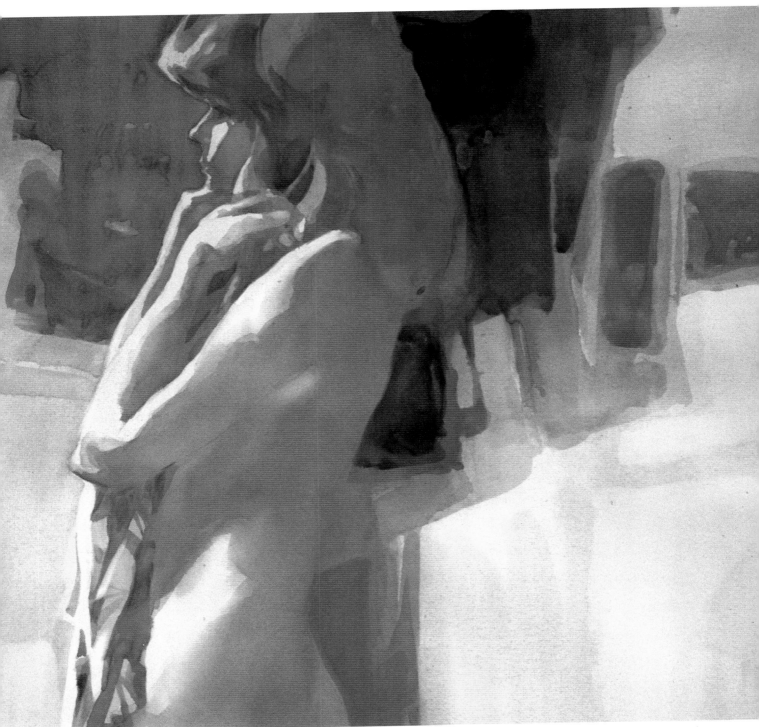

LINDA DRESSING, watercolor on Arches cold-press paper, 22" x 30" (55.9 x 76.2 cm).

LINKAGE

We can begin to better organize and simplify the various parts of the figure through the use of linkage. Linkage can be created on the shapes of the model by having the model pose under a strong spotlight. Spotlight lamps and stands can be purchased at most hardware stores. The spotlight bulb strength should be a minimum of 100 watts. Place the spotlight on the model podium and have the model pose under it so that part of his or her body is in the light and part is in the shadows (in this case, we'll place the spotlight on the right side).

Squint your eyes and look at the model in terms of what shapes are in the light and what shapes are in the shadow. Notice how the light hitting the model on the right side links the face to the shoulders and arms. Also, note that the left side of the model is brought together by the linkage of the shadow on the left side of the hair, face, shoulder, and arm.

Rather than thinking in terms of anatomical parts, think in terms of the simple linkage of shapes created by the light and shadow. For example, instead of looking at the hair, eyes, nose, mouth, and chin, look at the shapes created by the linkage of light and shadow that flow across the face.

Spotlights can be purchased at most hardware stores or camera shops. Some come with a tripod stand, while less expensive types have a clamp and can be attached to an easel or a corner of the background frame of the model stand.

To see how the spotlight creates a relationship or linkage between the various parts of the figure, first let's look at how the model appears on the stand with normal lighting. Here, I've asked her to pose without a spotlight; she is lit instead by the room lights, which are all around the model stand. In this situation, light comes from all directions, and it hides the form or shape of the model. We see a mostly two-dimensional structure of parts (hair, eyes, nose, arms) and have only the parts to paint. The hair has no relationship to the face, the face has no relationship to the neck or arms, all the parts are separate.

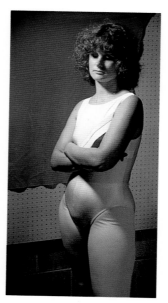

Now I turn off the room lights and ask the model to turn on the spotlight that is placed just beside the model stand. Look at how the light connects the various parts of the model's face, hair, torso, and arms together. The shadow pattern also unifies her anatomy and explains the structure of the model in a more three-dimensional way. The separate anatomical parts are related through linkage. We are no longer forced to paint the hair as different from the face, but can now see and paint the avenues of light and shadow that connect the hair and face, and so on down the figure.

To gain a better working knowledge of the concept of linkage, first construct a simple silhouette of the entire form. If you feel more comfortable making a quick contour sketch of the figure, by all means do so, but make the drawing gestural. It's not necessary to have the entire figure on the page, but do allow a good amount to be shown so that you are able to see how linkage connects the different anatomical parts. Any color will work at this point, but I'm staying with a fairly honest representation of flesh by mixing a combination of raw sienna and alizarin crimson for my light wash. After the figure is painted in silhouette form, allow the paint to dry.

Now mix an obviously darker value of the same or another color (in this example, I've mixed a stronger value of the same alizarin crimson and raw sienna). Make enough of this mixture to complete the entire painting. Begin the second phase of the exercise by painting in not the face but the shadow pattern that flows across the face. The idea here is to allow the pigment to flow across the separate parts, such as hair, cheek, nose, without stopping at the edges of these individual parts.

Notice that the shadow pattern on the model does not stop at the chin or the edge of the hair, but continues down into the shoulder and torso, in effect linking these various parts together. As you continue to paint the simple pattern of shadow on down the torso and into the legs, be aware that though you haven't painted individual parts such as eyes, hair, collarbone, or rib, a good deal of information is being explained by the division of light and shadow.

Now quickly add some linkage of shadow into the arm and hip on the left side of the figure where it appears, then step back and take a look at the information the pattern of light and shadow provides. You have constructed an image of the figure by pulling the many separate parts together. You haven't constructed a finished painting here, but a simplified foundation on which the finish will rest. Information about the structure is given without sacrificing the unity of the entire form. In short, you are pulling the figure together rather than pulling it apart.

THINKING IN TERMS
OF LINKAGE

Notice that the anatomical parts of the figure are not totally in the light or totally in the shadow. Because only part of the head is in the light, the light shapes reflect not the shape of the head but an abstract shape that will be unique in every pose. To demonstrate this, make a quick line drawing of the figure. Now draw a line that divides the figure into a light-and-shadow pattern. Then cut out the light shapes with a pair of scissors or a razor blade. The cutout is an abstract pattern of light rather than an image of the figure. Rather than thinking in terms of the hair being completely different from the face and the face being completely different from the neck or shoulder, you are able to link these areas together by thinking in terms of what is in light and what is in shadow.

When you look at the model at the beginning of the later painting session, rearrange your thinking from painting parts of the anatomy to painting the linkage of lights and shadows. Don't try to paint the anatomy; instead, begin by looking at and painting the linkage of light and shadow. The shapes you will make with your brush will not be brushstrokes of arms and legs but shapes created by the light and shadow as they travel across the planes of the figure. This isn't the finish of the painting, but it is a good plan with which

to begin your interpretation. In effect, this is the beginning phase of the figure painting. You will probably need to introduce more detail or explanation before the painting is complete.

Linkage is the tool that quickly unifies the subject, pulls the parts together, so the painting is ready to receive a little interest or detail. Linkage is a generalized statement in the beginning of the painting that ultimately prepares the artist to get some idea of where the interest needs to be added and where it can be left out. Linkage is not the finish but a solid framework on which the finish can be placed. Be aware that when the linkage of the light-and-shadow pattern has been established, the painting will usually be a little closer to a happy finish than you may have suspected at first. Much less detail may be needed than you thought. Some areas play proper supporting roles as nonfinished areas. If you can start by eliminating most detail through the use of linkage, you can unify the subject. Then you can step back and make some artistic decisions as to where the detail might best be placed and, just as important, where it might best be left out. Use linkage of light and shadow to create the foundation of the painting, then introduce the detail as it is needed.

To illustrate how the light and shadow become abstract forms rather than reflections of anatomical parts, I made a simple line drawing of the model posing under a spotlight, then drew a line on my paper to divide the figure into an area in light and an area in shadow, following the pattern of light and shadow on the model. With a razor blade, I cut out the silhouette of the figure drawing to free it from the paper, then I cut the figure in two, following my dividing line of light and shadow. The first example is the pattern of light. Notice that this light pattern creates alternating thick and thin abstract shapes rather than a reflection of the parts it represents. For instance, notice how thin the arm is in this example. The second example is the shadow pattern created in my drawing. The pattern of shadow weaves in and out of the various parts of the figure and develops a connection, or linkage, between them.

To further illustrate how powerfully the linkage of light and shadow can visually describe the complexities of the figure with a simple pattern of shapes, I took an arbitrary cool color (cerulean blue), which is as far from the reality of flesh as I can go, and gave myself the limited goal of painting only the simple shadow pattern of the figure. Though the color is technically wrong, and I allowed myself to paint only the linkage of shadow, I was able to comfortably construct a believable image of the human form, using the powerful tool of linkage.

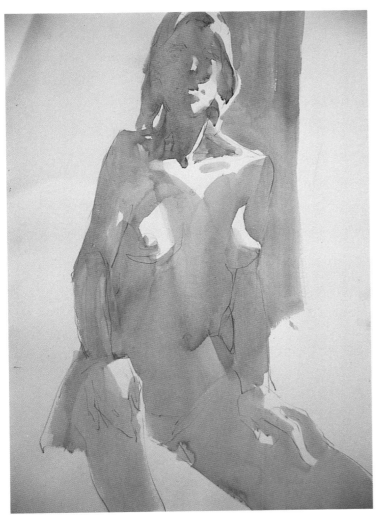

This linkage of light and shadow was created in the first twenty-five minutes of a one-hour painting session in a workshop and set aside to dry. I got caught up in a discussion and didn't get back to work on the painting until after the model had changed poses. Though some value development and refinements might well be needed, look how close this linkage pattern might be to a possible finish.

SIMPLIFYING THROUGH LINKAGE

We will discuss linkage of light and shadow as a start to figure painting for many reasons, but by far the most important reason is that it invites the artist to simplify the subject matter. The more complex the subject, the more we can rely on linkage to calm down the detail, to eliminate anatomical explanation, and therefore, to make a bolder, simpler statement.

To better illustrate, try a painting of a hand in a realistic way. Hold out your hand and make a quick sketch, then begin painting the hand exactly as you see it. There are so many informative lines and creases to be explained; every square inch of the painting is complicated and active; we can quickly destroy the painting with over-explanation. As is usually the case, when we accurately paint reality in any subject, the painting becomes far too busy (A).

Now hold your hand in front of the spotlight and look at it in terms of light-and-shadow linkage. Put aside the concept of painting anatomy, and focus on answering the question, "What's in light and what's in shadow?" Concentrate not on the parts but on the areas of light or shadow that flow across the parts of the hand. Now this complex subject has been boiled down to a much simpler and bolder statement (B).

One of the most valid lessons of our first year of watercolor is to learn to start the painting with a start—not a finish. Knowing that there's more to come, we begin with the extremes of simplicity. In other words, we start with the general and paint toward the specific, working from the overall picture to the details. As we discussed in the chapter on simplicity, the more we are able to simplify (through linkage), the bolder the subject becomes. We begin to tell more of the essence of the subject, rather than its complexities. Use linkage to aid you in this search for simplicity.

A

B

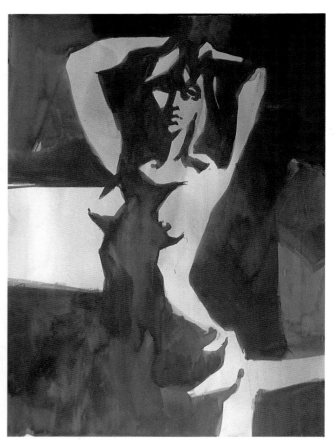

The shapes created by the patterns of light and shadow do not reflect anatomical parts. Though in our mind's eye we see arms, face, and torso, if we look at each shape individually, we see unique abstract patterns rather than a reflection of the anatomical parts they represent. In this example, at first glance we see the model adjusting her hair, but when we look at each shape of light and shadow individually, we see a variety of small, medium, and large abstract patterns. By boiling down the anatomy of the figure to this abstract interpretation, we develop unity and simplicity in the painting. We understand the structure of the figure without stating its complexities. Once this unified pattern has been established, we can develop detail or interest where we feel it is necessary without sacrificing the overall organization of the painting.

PASSAGE

Linkage not only pulls the separate parts of the figure together but also gives us a way to visually get from one part to the next. This visual movement is called "passage." Through passages of light and shadow, we are able to move our eye across the figure without stopping at the borders of the parts. For example, though the hair might stop at the shoulder, the shadow on the hair jumps across to form a passage with the shoulder, and on down the arm, and so on. Passage allows the viewer's eye to move in and out of the form, in and out of anatomical parts, to look through individual parts to a much larger and bolder form.

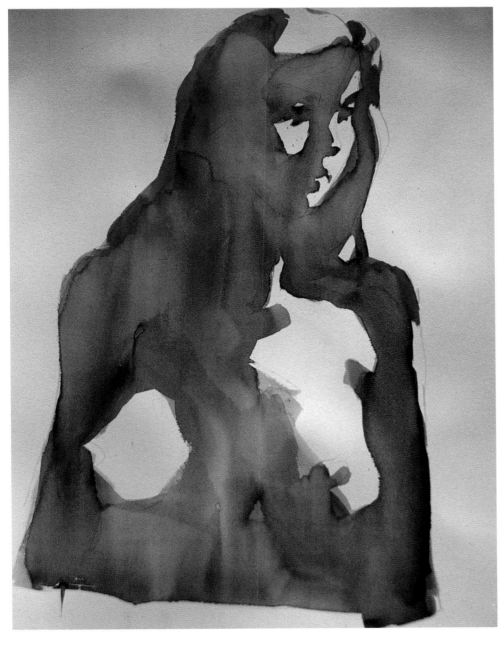

In this example of passage, I've left the white of the watercolor paper for the light areas of the figure and constructed a passage (or avenue) for the eye to travel through the subject matter by following the shadow pattern. Notice how easily your eye moves across the planes of the figure without having to stop at the edges of the anatomical parts. The light is necessary to explain the form so that we understand the subject matter of hair, eyes, arms, torso. The shadow pattern is employed as a passage to allow our eye to travel from one informative light to the next.

LINKAGE WITH COLOR

It certainly isn't necessary to develop the linkage of light and shadow by mixing and painting with just one color. With watercolor, we have the ability to easily unite various colors by allowing one puddle of pigment to blend into the next. As long as these various colors are welded together, linkage will be established.

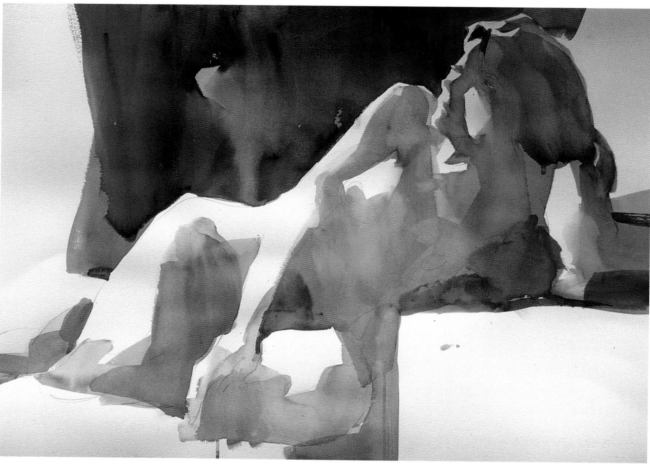

In this example, I am overstating the strength of the color changes that can occur within the framework of the linkage of shadow. Though the pure tube colors may appear a bit raw in places, the linkage of shadow is apparent.

When we create linkage using just one color, the shadow shapes will often appear flat. To add body and variety to shapes within the linkage, I usually alter or add some variety of color so that the linkage will appear more three-dimensional and have more character or interest. Look for the areas within the boundaries of the pattern of linkage that turn away, come closer, or are lighter or darker, and suggest these changes by altering the colors.

DETERMINING THE PATTERNS OF LIGHT AND SHADOW

When we are establishing the linkage, it's usually a good idea to find a balance of light and shadow, but generally an even division of these elements looks a little predictable and usually isn't exciting (A).

As artists, we have the ability to move the light around until we find a more interesting display of light and shadow. Usually when the model poses under the spotlight, there will be some areas of light in the shadow and some areas of shadow in the light. As artists, we should develop the patterns of light and shadow not only where they really exist but where we would like them to be. Push them around until you find a more striking arrangement (B).

When looking at and painting the linkage of light and shadow, consider that these patterns alternate as they travel across the figure. In some areas on the model, the pattern of light will be large and simple; in other areas, the pattern of light will be small and interesting. The same can be said for the shadow pattern. Light may be found just on the edge of one shape, while another shape or area of the figure may be bathed in light. Look for and paint as much variety in these patterns of light and shadow as possible. The more variety you are able to express in the linkage of light-and-shadow patterns, the more visually interesting the patterns will become.

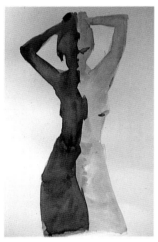

A

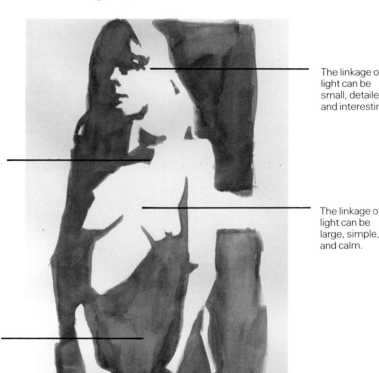

The linkage of shadow can be small, detailed, and interesting.

The linkage of light can be small, detailed, and interesting.

The linkage of light can be large, simple, and calm.

The linkage of shadow can be large, simple, and calm.

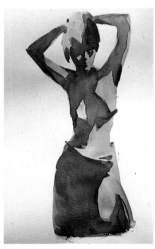

B

Once I have the drawing established on the watercolor paper, my first concern in most paintings is the explanation of the linkage of light and shadow. In this particular pose, the great majority of the details of both the model and the coat have been lost in the large, simple shadow pattern that flows across the front of the figure. I decided to leave the lights mostly white and to keep them in focus so that they would tell the story of the form of the figure. By contrast, I painted across the borders of the form to allow the shadow pattern to create a passage that hides most of the various anatomical shapes. Hair flows into shoulder, shoulder into torso, and so on. When first painting the coat, I made no distinction between the fabric and the flesh. I was painting not the coat but the shadow that flows across the coat. After this was accomplished, I went back and introduced hints of changes in color and value so that there would be some distinction between the figure and her garment, but first and foremost, I wanted to establish linkage between them to show how they belonged together before I indicated how they might be different.

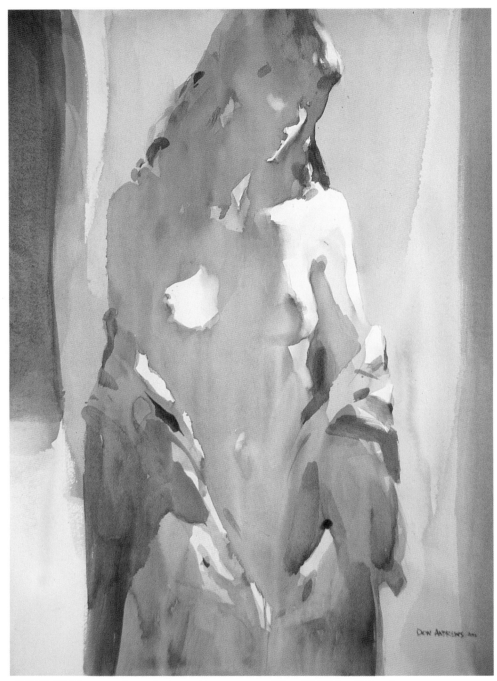

JEAN'S COAT, watercolor on Arches cold-press paper, 33" x 30" (55.9 x 76.2 cm).

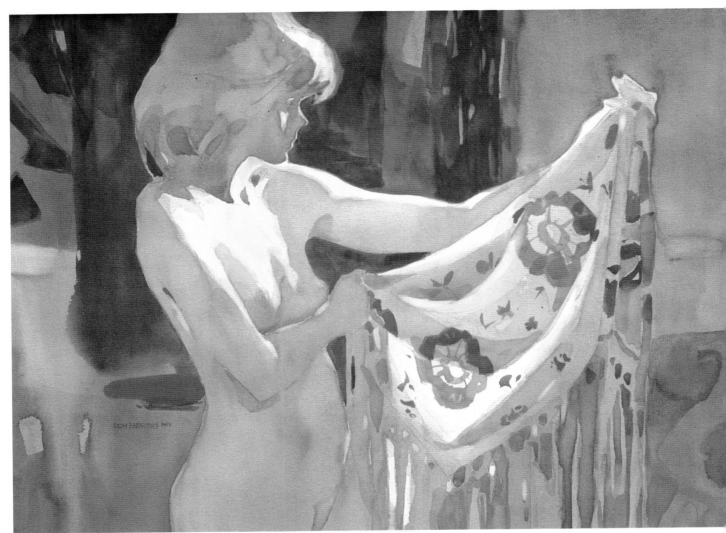

DONNA AND SHAWL, watercolor on Arches cold-press paper, 22" x 30" (55.9 x 76.2 cm).

The main concern at the start of this painting was unity. The figure and fabric were so obviously different, yet they depended on each other to make the pose balance. Linkage of the patterns of light and shadow is again employed to weld these two different characters together into a more unified structure.

Notice that the light on the model's face and chest continues across the top of her extended arm and connects with the light on the top fold of the shawl. The cool shadow pattern on the bottom of the shawl jumps across and continues as a cool shadow on the model's stomach, bonding them together.

PAINTING THE GESTURE

One of the best ways to learn to simplify the details and busy shapes in the figure is by doing a series of quick gesture paintings. Again, the idea is to turn our attention away from reporting the details of the figure and to begin focusing on the essential overall shapes of the figure and their relationships to one another—in essence, to begin looking at the figure as one form. We will, admittedly, be making abbreviated interpretations of the figure rather than striving for finished renderings.

I think it is advisable to do a series of quick gesture silhouettes rather than spend a great deal of time on one particular pose. This is not the time to do a finished painting but a time to explore—to explore not just the form of the figure but also our feelings about shape, color, and brushstrokes. In this way, we will develop a new sense of freedom and looseness in our brushwork, which will be a rewarding addition to our more finished works. Also, by doing these quick gesture drawings, we will begin to teach ourselves to see more clearly how the entire figure is involved in every movement or action the model makes. Notice how the weight shifts from one leg to the other when the model raises one arm over his or her head or how the left shoulder drops when the head is turned to the right. Many people assume that figure painting consists of explaining tiny details of the anatomy. But it is when we begin searching for a better understanding of how the overall shapes of the figure interact and affect each other that we give life to a fluid figure statement.

When describing the figure in gesture painting, I suggest you use your largest round brush (No. 24 round or larger) or a one-inch or wider flat brush. This will help you avoid busying up areas within the form and will also help you begin to abbreviate and interpret shapes into a more personal statement.

Make your paintings on large, inexpensive sheets of student-grade drawing paper, 18″ x 24″ (45.7 x 61.0 cm) or larger. Any grade of paper will work as long as water runs or puddles on the surface rather than soaks through to the other side. Student-grade drawing paper can be purchased at most art supply stores in pads of fifty to one hundred sheets. I think it's important to use inexpensive paper so you won't worry about taking chances or experimenting.

Tilt your paint board up to an angle of about seventy-five degrees so the paint runs down the paper

rather than forms puddles. This will allow the paper to dry faster and wrinkle less. Though some buckling will occur on the paper, don't be concerned at this point. You are looking more to broaden your understanding than to do finished paintings.

I will discuss color in detail in a later chapter; however, at this point let's say that "anything goes." Try using as many varieties of color as possible for the gesture painting session. I won't say that using an obvious color such as a pinkish tan mixture of flesh is wrong, but realize that it is just one possibility for these experiments.

Rather than drawing or painting an outline of the figure in advance and then just filling in the lines, begin by looking at and painting the mass of the form in

silhouette gestures. Strive for the overall shapes that describe the pose rather than the details that fill up each separate part.

For the first gesture painting session, have the model change poses every two minutes, just as in a gesture drawing session. Remember to take a few moments first to gain a visual understanding of the overall pose, then concentrate more on your painting and less on the model as you begin to paint. Don't be concerned with painting the hair differently from the face or explaining the changes that occur within the outside boundaries of the figure. The goal here is a fresh, interpretational silhouette of the figure. Work quickly and keep your brushstrokes large and fresh, not labored.

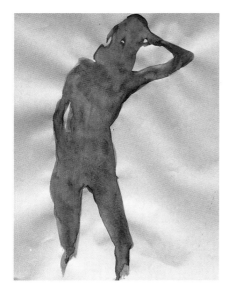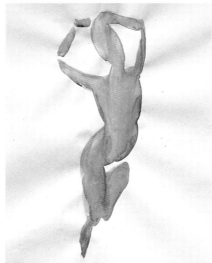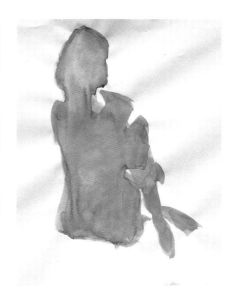

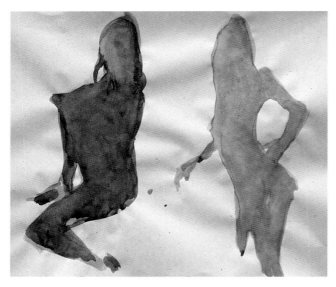

By doing a continuing series of quick gesture silhouettes, we gain a better understanding of how the human form is totally involved in every action the body makes. For every action that takes a part of the body out of balance, there is a reaction by other parts of the body to bring it back into balance. Gesture paintings sensitize the artist to these automatic redistributions of weight and will translate into a more knowledgeable interpretation of the figure.

INTRODUCING LINKAGE
OF LIGHT AND SHADOW

For the next gesture painting session, let's go a step further and begin looking at the figure in terms of the linkage of light and shadow. Have the model pose under a spotlight, partly in the light and partly in the shadow. Ask him or her to change poses every three minutes. Again, tilt your board to allow for quick drying.

As the model strikes a pose, first put down a simple gestural silhouette, just as in the previous exercise. Allow a few seconds for the paint to dry. Now mix a stronger value of another color in your palette. Any color will do at this point, as long as it is obviously darker in value; however, allow your taste to have a say in your color choices.

When you have mixed a good amount of the darker color, stop and take a few seconds to notice how the shadow forms a pattern across the figure. Don't think in terms of hair, face, arms, or legs (anatomical parts), just look at the shapes of the shadow pattern. With the darker color, quickly paint a linkage of shadow pattern on top of the silhouette you just painted. Notice that when you cut into the silhouette with the shadow pattern, you are able to give a simple explanation of the structure (such as arms and legs) that is found within the outside edges of the figure. Also be aware that you are able to begin identifying these parts without cutting them out or separating them. You have, through the tool of linkage, created a simple passage that allows the eye to move from one anatomical part or area to the next without being stopped at the borders of each part. You are introducing a new dimension to the structure of the figure, yet you are still able to see it as one complete shape. You are not only explaining and simplifying a complex structure but also relating the various parts of the structure to one another.

Though you are working gesturally and calling the exercise an experiment, I truly feel that this concept of painting the linkage of light and shadow is one of the most important lessons about figure painting to be gained from this book. The success of your more finished paintings will hinge to a great degree on your ability to link the shapes of the figure together in terms of light and shadow. The added explanation of detail that may be necessary in a finished painting will be painted over this simplified structure that holds the figure together. Again, don't think in terms of painting features. Think in terms of painting linkage.

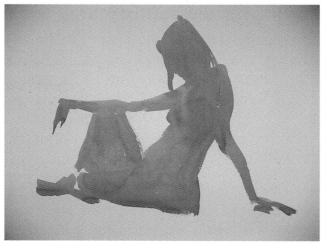

To create a simple pattern of linkage, I begin by painting a silhouette of the entire form. I try to look for weight distributions that explain the particular pose. In this example, the weight of the torso is being held by the model's left arm so the arm angles out firmly to the side. The lifted right knee supports the right arm, so the right arm is limp in comparison to the left arm. The head bows forward, creating tension in the back of the neck, and strands of hair fall forward, covering the model's face. After I suggested these actions in my silhouette gesture, I stopped a moment to allow the painting to dry.

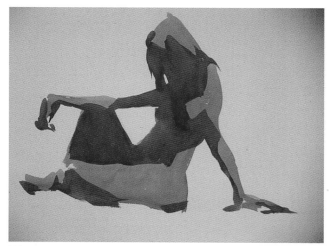

While the silhouette was drying, I mixed a darker value of pigment in my palette mixing tray. In this particular instance, I used a middle value of cadmium red. My first action was to look at the linkage of shadow uniting the front of the model; with that firmly in mind, I began to introduce the pigment onto the shadow pattern of the figure, starting with the front of the hair and face and moving right down into the torso and raised right leg. The inside portions of both arms are also in shadow, and there is some shadow under the left leg. Though this particular shadow under the left leg is physically separated from the other linkage of shadow pattern, the eye will read this area of shadow as a continuation of the overall pattern of shadow.

GESTURAL ATTITUDE

Why is it that we display wonderful handling and beautiful brushstrokes in these quick, interpretational gesture paintings, yet when we get out the good paper and slow down the pose, these positive qualities often seem to disappear? I think our paintings change when our attitudes change. In the gesture paintings, we aren't overly concerned with being careful. We are allowing the brushstrokes to hint at the subject matter rather than copying it. In short, we are inventing (or interpreting) the subject. In the longer poses, when we have time to be careful, we begin to have preconceived notions of how the painting is supposed to develop. We often try to force the brush to explain the figure in a calculating manner. We become tedious, and our painting reflects this attitude.

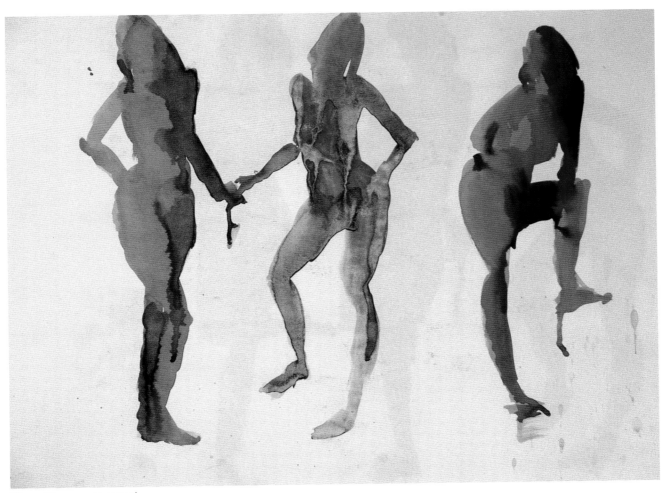

The willingness to experiment always seems to pay dividends. Unique shape arrangements or color mixtures in finished paintings are often first discovered during the gesture painting session.

TIME TO EXPERIMENT

Maintain an experimental attitude. Be ready to try any possibility that comes to mind: new colors, values, brushstrokes, or shape arrangements. Allow your imagination to flow as it will. This is a time when "anything goes." Trust your senses and feelings, and follow them. See what new and exciting directions they can take you in. It's okay to have a good time during this experiment. Reserve judgment during the gesture painting session and don't stamp "good" and "bad" on each painting.

I usually tell my class, "If I can look at your painting and put the model back into approximately the same pose, then you have painted a successful gesture painting." Don't expect all the paintings to be equally successful. In fact, expect just the opposite. You will react a little differently to each pose, depending on your taste, understanding, likes, and dislikes.

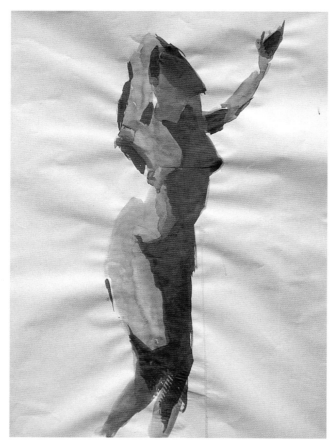

By making a conscious decision to try unique color combinations and continually arranging the figure on the page in different ways, we gain new insights into what the possibilities for exciting painting can be.

NEGATIVE SHAPES

Let's try another gesture session. Up till now, we've been painting the figure as a positive image with a background of white paper as the negative space. Now let's reverse this format and paint a few two-minute gestures in which we develop the figure by painting the background area that surrounds the model, so that the figure becomes a negative white shape.

Don't try to be too careful here. The goal isn't so much to depict the figure as to gain a better understanding of the figure as one total shape. You are teaching yourself to see the negative shapes created by the positive shapes of the figure and gaining a broader understanding of how movement affects the entire figure rather than just one area or limb. Your thinking evolves from painting things to painting shapes.

By painting the figure as a negative shape, we see the figure as one total form rather than a conglomeration of many separate parts and pieces.

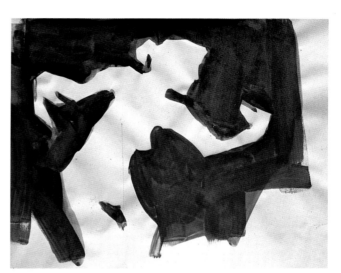

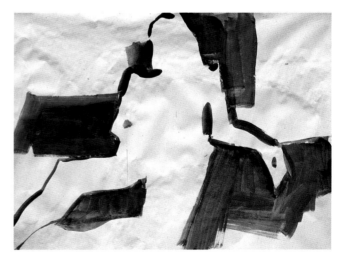

INTRODUCING A BACKGROUND

We have much more to learn about the possibilities for development of the figure, but I want you to stop here and consider that as important as the main subject of a painting is, the figure is only part of the total painting. The background areas around the figure will have a lot to do with whether the painting is successful or not. In other words, no matter how well we paint our main subject (the figure), if the supporting areas around it fail, then the painting doesn't work.

Backgrounds can be a variety of things. They can be recognizable objects or abstract shapes. Backgrounds can be interesting or simple, in focus or out of focus. Regardless of what a background is, however, its role in a figure painting is basically the same: to enhance or complement the figure.

In order to better realize how a background might be developed, we can benefit from some understanding of the basic elements of design. I don't have a complete definition for "design," but its seems that when a painting is well designed, that fact is easily recognizable. In most paintings that have a well-structured design, the artist seems to have paid some attention to the organization of shapes throughout the painting.

I believe that most of us have a good sense of design, but all too often we become so involved in explaining the complexities of the subject matter that we don't allow our design abilities to have much effect on the outcome of the painting.

To exercise our design muscles, let's do some experiments where our attention is directed to organizing the page rather than just explaining the subject matter.

TERESA, watercolor on Arches 140 lb. cold-press paper, 22" x 30" (55.9 x 76.2 cm).

A background functions as an integral part of a painting. It must balance and enhance the forms of the figure. In *Teresa*, the background shapes echo the patterns and colors found in the figure. Note that although the dominant arrangement of shapes is vertical, a thrust that follows the forms of the model, the picture is counterbalanced by a strong splash of horizontal color and shape.

BALANCE

The most obvious way to create balance in a painting would be to allow half the shapes to be placed on one side of the paper and then repeat this same display of shapes on the other side; a perfect balance would be created. In painting, however, equality is often visually monotonous. On the other hand, visual excitement can be established by balancing shapes through the use of variety and contrasts. In the same way that boys balance girls or night balances day, so too do large shapes balance small ones; warm colors balance cool colors; in-focus shapes balance diffused or out-of-focus shapes. By creating balance with contrast, the artist is able to create order without monotony.

To better explain the possibilities of this concept, let's take the four shapes in this illustration to a professor in the math department of our local university. If we ask the professor to organize or balance the four shapes on a rectangular piece of paper, the first example (A) might be the arrangement he or she would come up with. We can't say this shape arrangement is wrong, but to the artist, the equal balance of shapes or division of space seems predictable and is visually boring.

Now let's take the same four shapes to the art department (which can usually be found somewhere *behind* the math building) and ask an art professor to repeat this exercise. In the art professor's example (B), the balance of shapes and space is equally evident; however, this time large shapes are placed so that they create a feeling of harmony with the small ones. Active areas of space are balanced by calmer areas of space. We have created balance on the page without the boredom of equality and symmetry.

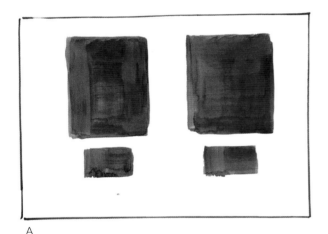

A

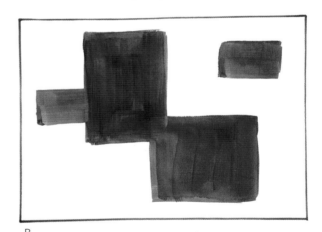

B

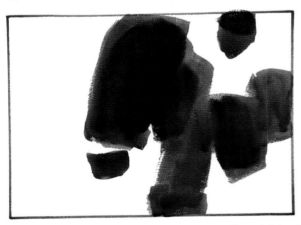

In this abstract painting, the goal is to arrange a group of shapes on the page so that they appear to be balanced. There seems to be a problem at this point in the painting because the shapes are situated in the middle and right of the painting with no counterbalance of form on the left. Do you agree? What shape or shapes might be added to bring the painting into a more pleasing balance?

I place additional shapes on the left, and the painting now appears to be balanced more to my satisfaction. Do you agree? Remember, there is no right answer here, and each artist might find a slightly different way to organize the painting. It is by looking at the objects or structures in a painting in terms of shapes that we become aware of their organizational possibilities.

BALANCING SHAPES

In order to focus our attention on organizing and balancing the background shapes in our painting, it is helpful to think of the model as a simple silhouette rather than as a complex human form. When we mentally reduce the figure to an abstract shape on the paper, we can begin to ask ourselves what other shapes could be added to better balance it.

As painters (realistic or abstract), we balance the images in our paintings through the use of shapes. These shapes may indicate recognizable objects, such as arms, faces, figures, chairs, or windows, or they may be abstract shapes that indicate space, size, or distance. As painters, we are both shape makers and shape arrangers.

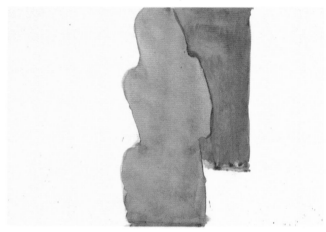

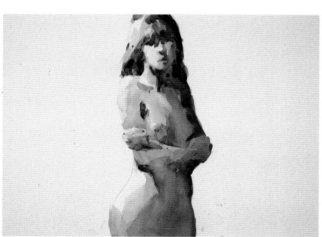

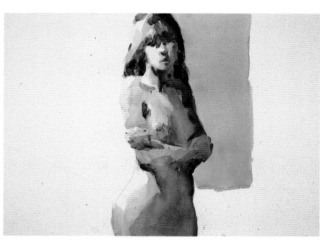

It might be easier to think of the figure as a simple shape and to discover ways to arrange additional shapes around it if we could overlook the details and activity that occur within the structure of the figure and instead think of the figure in abstract terms or as an abstract silhouette. Now ask yourself what simple shape might be placed on the page to counterbalance the silhouette made by the figure.

By adding another shape to the page, I have begun one possible arrangement of abstract shapes. Listen to your feelings here; remember there isn't one clear-cut right answer but endless possibilities for shape creation and arrangement. At this point, do you feel the shapes on the page are beginning to make too much of a vertical pattern? If so, then place a medium-size shape on the right side to stretch the pattern of shapes horizontally.

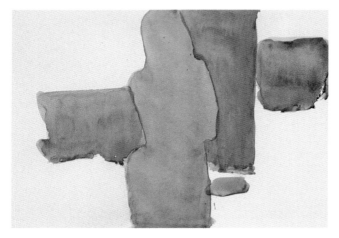
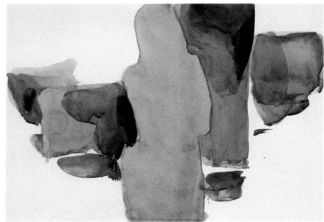
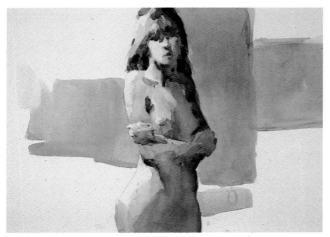
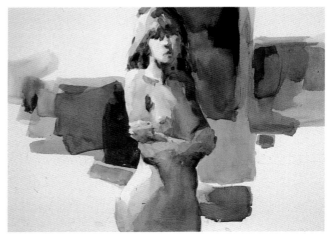

As soon as the horizontal shape is placed on the right, do you feel the need to counterbalance with a shape on the left? Should this counterbalancing shape be equal to the horizontal shape in size and weight and placed directly opposite it, or could the new shape still balance if we alter its color, size, and placement?

As I continue to follow my design sense and add shapes to the painting, the page begins to feel more pleasing in balance and organization. Step back and view the painting from across the room.

When are we finished? I never really know, but again, let your taste decide. There may be a lot of shape-building necessary to organize one pose and just a few shapes needed for the next.

After making a drawing of the figure on my watercolor paper, I try to get some idea of what background shapes might be needed to better organize this extremely horizontal pose on the page. First, I cover the figure with a variety of light washes so that I can more easily see it as a simple form. Once the figure is washed in, I allow some of the wash to sneak out into the background behind her head to hint at some background shape behind her. I am keeping the wash fairly light at this point so I can alter the background shapes if I need to. As soon as I create the shape behind the model's head, I realize some possibilities for counterbalance of shape in the lower right side of the page, just below the model's leg and hip. So I allow the wash to flow through the borders of these areas and down into the space below. At this point, what I've created is not so much a figure painting as a distribution of light-value shapes on the page. I'll stop here and let the painting dry.

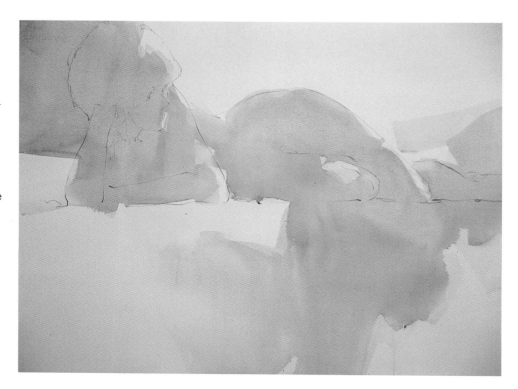

Once the painting has dried, I feel the need to work back into my main character (the figure) to bring it more into focus. I generally like to develop the figure first by bringing it a little closer to finish and then allow the background to catch up or bring it to about an equal stage of completion. This way, there is no danger of the figure being overpowered by its surroundings.

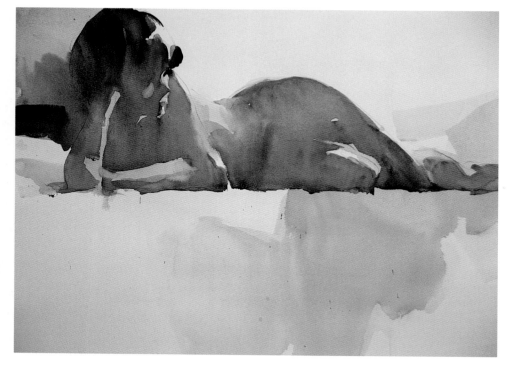

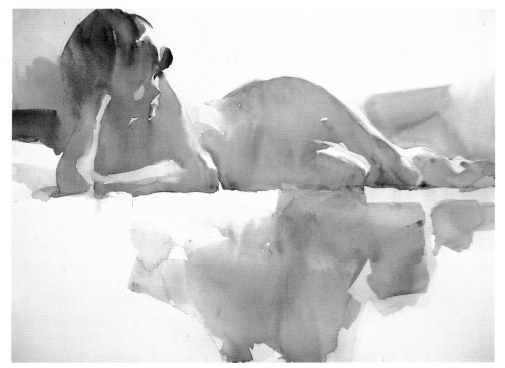

Once the figure has been established, I bring some background shapes into focus by dropping down their value and giving them a little firmness in edge quality. I quickly soften some edges again so that the shapes around the figure are not quite as distinct or in focus as the figure. For instance, the horizontal shape located just behind the model's hip is painted in firmly at first, and then I soften it as it gets closer to the edge of the right side of the paper. I'm a little bothered right now by the dark shape at the left of the painting, just behind the figure's arm. It was put in to balance the dark in the model's face and hair, but at this stage, it seems a little too demanding and out of balance.

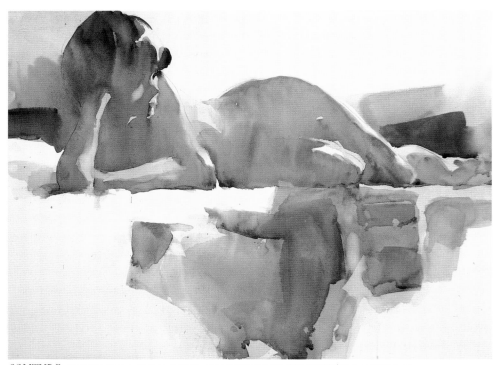

SOLITUDE, watercolor on Arches 140 lb. cold-press paper, 22" x 30" (55.9 x 76.2 cm).

In the final stage of the painting, rather than wash out the bothersome dark shape on the left, I've decided to counterbalance it with a similar dark shape on the right, just behind the model's calf and foot. A few more hard-edged middle-value shapes are introduced into the lower foreground, as I feel it needs a little more clarity. I don't want to make this area so interesting that it steals the attention away from the figure, so I just add a little form and step back to see if more interest is needed or not. Notice how the hard-edged shapes in the middle foreground seem to point to the main character, the figure.

Since there is a good deal of interest and detail within the framework of the figure in this particular pose, I decided to keep the background shapes fairly large and nondemanding. The large warm mass just behind and to the left of the seated figure is balanced by a smaller, some-what similar version of this color and shape on the right. The three negative white shapes are balanced in "zig-zag" fashion by being placed at the top right, middle left, and bottom right. Though they are the same value, each negative white space has a different weight and shape.

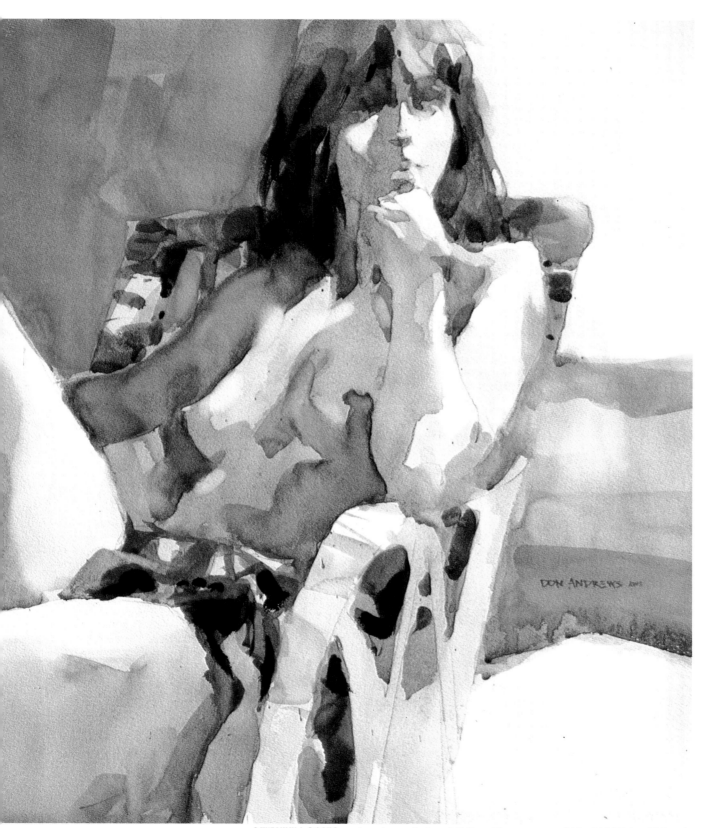

BETWEEN POSES, watercolor on Arches 140 lb. cold-press paper, 22″ x 30″ (55.9 x 76.2 cm).

CREATING A SENSE
OF SCALE

Scale can be said to be the visual tool the artist employs to give the viewer two important types of information. First, the artist uses scale to tell the viewer about the sizes of the shapes in the painting. Second, through the use of scale, the artist is able to indicate where the interest or excitement in the painting will be.

Scale can be created by developing contrasts in the sizes of the shapes within a painting. By establishing a great deal of variety in size, the artist in effect gives the viewer a better understanding of what the sizes of the various shapes are by comparing them with one another. Put another way, we can say more about what small shapes are by also saying a little bit about what small shapes aren't.

In the first painting (A), I have created a sense of scale by developing the shapes in a variety of sizes and weights. By consciously constructing large shapes next to medium-size and small ones, we are able to visually compare and better understand the sizes of the various shapes. This contrast of scale provides variety, which is visually exciting.

In the next example (B), I used the same colors and brushes, but this time I allowed all the shapes within the painting to be about the same size and weight, and so scale isn't as readily apparent. Since each shape takes up about the same amount of space as its neighbor, each shape demands about the same amount of attention. We thus have created a visual equality of the sizes of the shapes that becomes monotonous. Be aware that large shapes play an essential role in organizing a painting by visually giving proportion to middle-sized and small shapes.

A

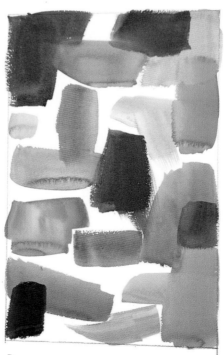

B

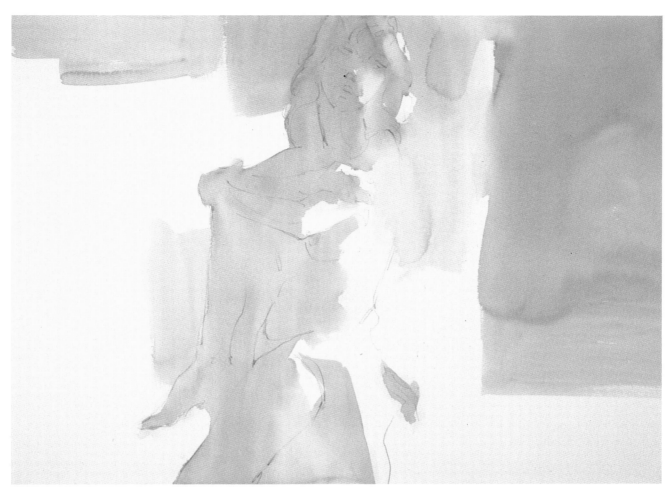

This watercolor illustrates how the concept of scale can be used to give an added sense of proportion and interest to the figure. After the figure has been drawn on the page, I decide to use the white of the watercolor paper for the linkage of light on the right side of the figure, so I begin by painting a light-value wash directly into the linkage of shadow, which covers a good deal of the model in this pose. Once this is established, I lose a few of the edges in the shadow pattern of the figure and allow the pigment to flow out into the beginning of a possible background, so that the figure doesn't appear "cut out," or separate from her surroundings. I'm working with a two-inch (5 cm) flat brush so that I can easily create large masses in the background areas with as few strokes as possible. It's easy to paint back into large shapes in a painting and thereby divide them into smaller shapes; the hard part, for me, is creating and saving large simple shapes. With this in mind, I concentrate on establishing a range of large and medium-size shapes, knowing I'll be adding some smaller, more interesting shapes shortly.

Once the paper is dry, I begin by working back into the shadow pattern within the figure. I am trying to establish interest within the figure or in terms of scale; I want to create small shapes within the figure, such as the lights and darks on the model's hair, face, and fingers. These small shapes will become the interest, or detail, of the painting. When these details are better established, I can begin to visually compare their size to the medium-size and large shapes in the background.

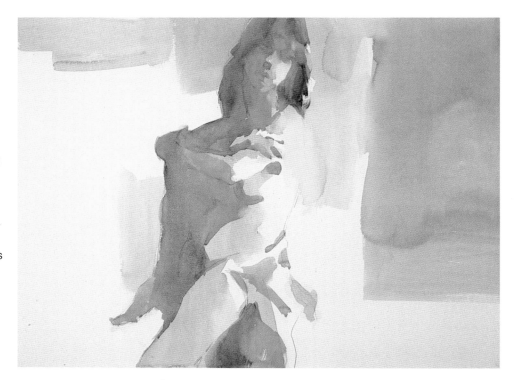

When we're working on the latter stages of a painting, we often have a tendency to automatically reach for the smaller or rounded brushes. In this case, however, I feel what is needed is an enhancement of the large and medium-size shapes. So, I reach back for my two-inch (5 cm) flat brush and reestablish these large shapes in the background. Their color and value will be adjusted, but care is taken not to diminish their size or scale. In fact, the one change in scale I'll make here is to enlarge the vertical shape that sits on the right side of the model.

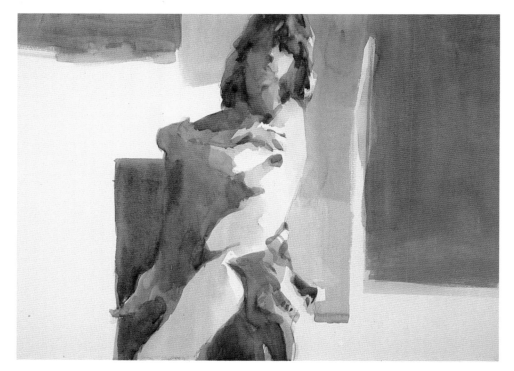

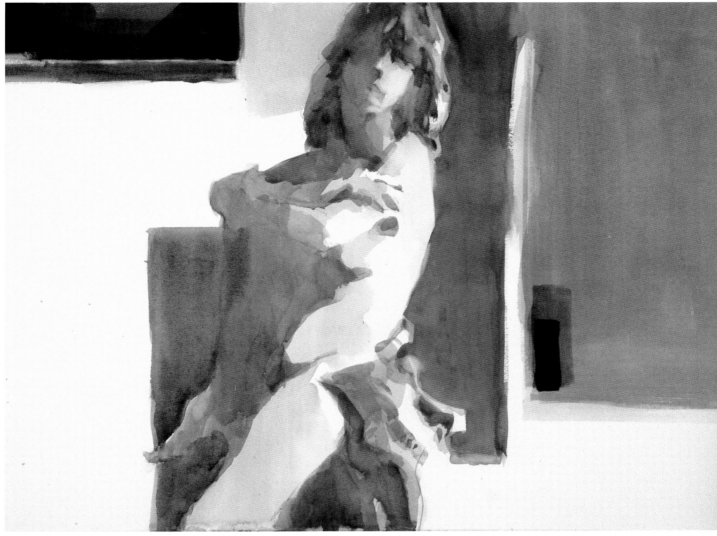

SHARON, watercolor on Arches 140 lb. cold-press paper, 22" x 30" (55.9 x 76.2 cm).

In the final stage of the painting, I want to develop a little more interest in the background without sacrificing the scale of the large and medium-size shapes, so I alter their color and value but allow them to retain their original size. I introduce a small dark-valued rectangular shape in the lower left corner of the large burnt sienna mass at right; this adds more interest and emphasizes the massiveness of the large shape. I want to counterbalance this darker-valued rectangle, so I introduce it again in the upper left corner of the painting and develop a little more interest there as well. Looking at the finished painting, I am very much aware of the interest displayed in the small shapes in both the figure and the background, but the effectiveness of these small and interesting shapes can only be realized when I develop a variety of medium-size and large shapes that allow the small shapes to become unique.

CREATING VISUAL INTEREST

We usually call the small shapes or brushstrokes in a painting "detail." Detail is an important element that adds excitement to a painting, but be aware that detail becomes interesting only when it is used sparingly. If a painting is filled with small shapes, this detail becomes busy rather than interesting. How, then, do we paint interest into our work? By leaving the busy out. In other words, we must limit the amount of detail or small shapes and create medium-size and large shapes as contrast.

Have you ever overheard a couple admiring a painting and whispering "That must have taken the artist forever to do!" Many people are impressed by a painting filled with tiny brushstrokes, but the trained eye is more impressed by the organization of detail, not the amount of it.

It's easy to get out a small pointed brush and fill a painting with tiny brushstrokes, but in doing so, we often create confusion rather than order. As artists, we should realize that small shapes generally attract attention. But just as important, the large shapes must be created if we intend to develop order in our work.

In the first example (A), I used scale to give some understanding of where the interest lies within a painting. The painting has a range of large, medium-size, and small shapes. The small shapes in the example play their proper role as detail or interest. However, be aware that the large and medium-size shapes also play their proper role by not competing with the small shapes for the viewer's attention.

In the second example (B), notice that I have painted the same small shapes of detail as in the first example. However, this time I develop new shapes around these small, interesting shapes to be about the same size and weight. Competition is established, and disorder is the result.

Since childhood, we have been taught that the more complicated something is, the better it must be. If we don't understand it at all, it really must be great! It seems the more buttons a stereo has, the more sophisticated it is. As artists, sometimes we have the same attitude about our work. But more complexity isn't necessarily better when we're painting.

I am constantly looking for ways to calm down the detail in a painting in order to better organize it. Too often, through habit, we pick up a small brush and begin busying up our paintings, when in most cases, just the opposite direction should be taken.

A

B

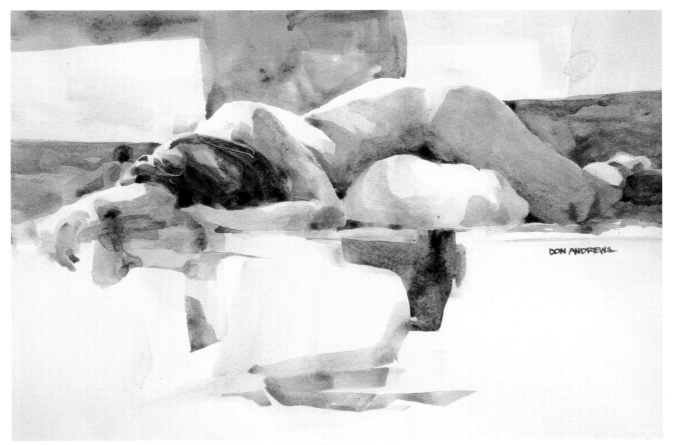

LINDA, watercolor on Arches 140 lb. cold-press paper, 22" x 30" (55.9 x 76.2 cm).

The challenge for me in most paintings is to create, balance, and save large, simple shapes. I try to keep the big brushes in my hand as long as possible, though the small shapes attract more attention in a painting and usually catch the viewer's eye. It's not too hard to pick up a small, pointed brush and make tiny brushstrokes, sprinkling the page with confetti. In this painting, the details found in the hair and torso attract the viewer's attention, but the success of the painting hinged more on the creation and organization of the large noncompetitive shapes and spaces.

NEGATIVE SHAPES

Until now, the considerations of interest, balance, and organization we have discussed have been developed through the creation of shapes painted on paper. Now let's consider that when we paint a positive shape, the surrounding areas of the paper become negative shapes. These negative shapes should be orchestrated according to the same concepts of design as the positive shapes are. That is to say, the negative shapes should be arranged with the same consideration of scale, balance, and interest on the page as the positive shapes are.

To better explain, look at the two illustrations. In the first example (A), the four negative white shapes are created by painting a crosslike positive shape that extends from the center to the four edges of the paper. Each negative shape is the same in size, weight, and interest as the others. We can't say that any of the shapes are poorly constructed in themselves, but because they are so alike, they tend to cancel each other out. They seem common and visually monotonous.

In the second example (B), we again see a positive shape that extends from the center of the page to the four sides. This time, care has been taken to alter the arrangement and interest not just of the positive shape but of the four negative white shapes as well. Now the negative shapes have variety and scale from large to small, unique characters, and different degrees of interest.

Rules just don't apply to painting, but we should consider that all painting is shape-making—both positive and negative. Shapes seem to become more exciting when there is variety in their size, placement, and interest. Variety and contrast increase the visual interest of both positive and negative shapes.

A

B

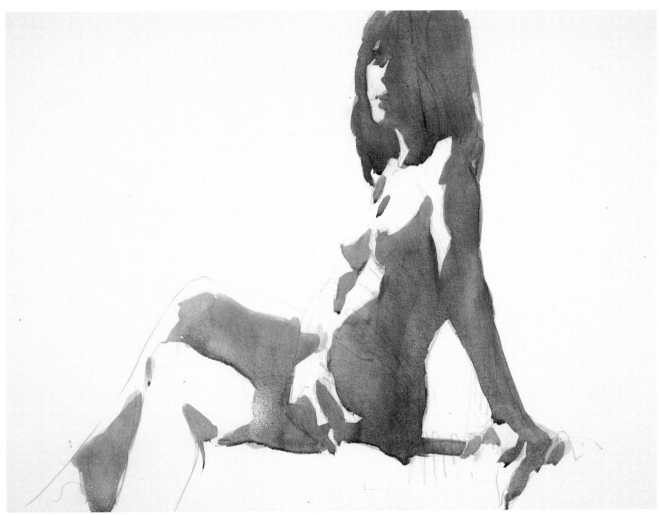

Now let's apply this concept of balancing negative shapes to a figure painting in order to better organize both subject matter and background. For this example, I used just one color and one value so that we can easily read each area of the painting as either a positive or a negative shape.

To create and balance negative shapes, we create positive shapes, and the space left by the positive shapes becomes negative shapes. In this example, the shadow pattern of the figure is constructed by developing a positive shape. The light pattern on the figure and the surrounding background area become negative shapes in the painting.

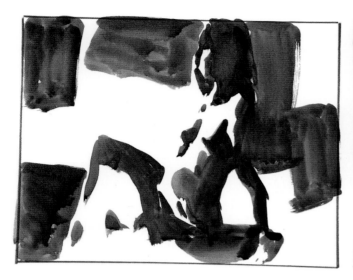

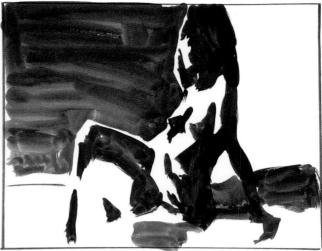

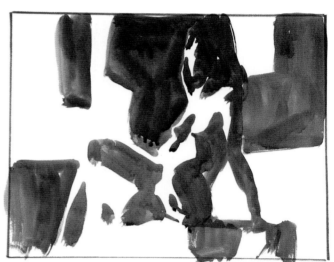

In order to give you some idea of the endless potential for development of negative shapes, I got out some student-grade paper and produced a series of possibilities, using the same pose in each thumbnail. The goal here was to develop the positive shapes in the background so that the negative shapes or spaces left on the paper would have a feeling of scale, balance, interest, and organization. Notice that each new arrangement of negative shapes creates a totally different painting, although the subject matter (the figure) is unchanged. In each new example, I've tried to place the negative shapes in a different arrangement than they were in the preceding one. None of the examples should be considered to be the one right answer, and certainly I'm just scratching the surface as far as showing the possibilities for development of negative shapes to create the feeling of organization on the page.

I looked through the series of thumbnail paintings and picked one that appealed to me. I'm not saying that this particular arrangement of negative shapes works better than the others, and I might well have picked a different one another time, but I do like the feeling of interest and scale in this particular arrangement. For instance, there seems to be a nice balance of linear, small, medium and large negative shapes. So I added these forms to my original figure painting to see how well they would work.

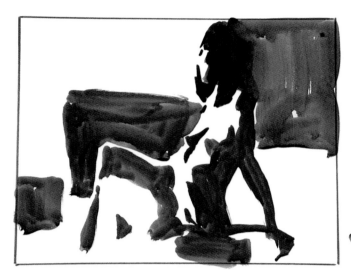

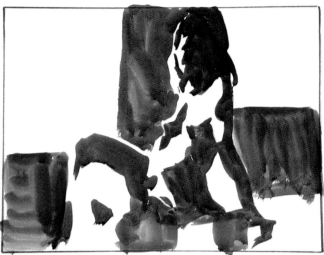

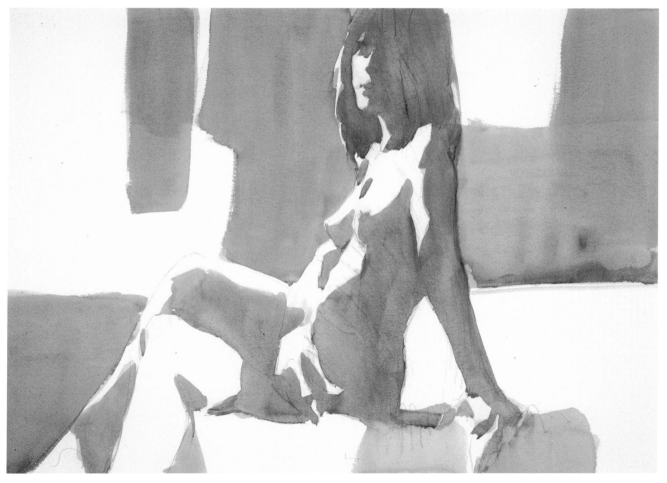

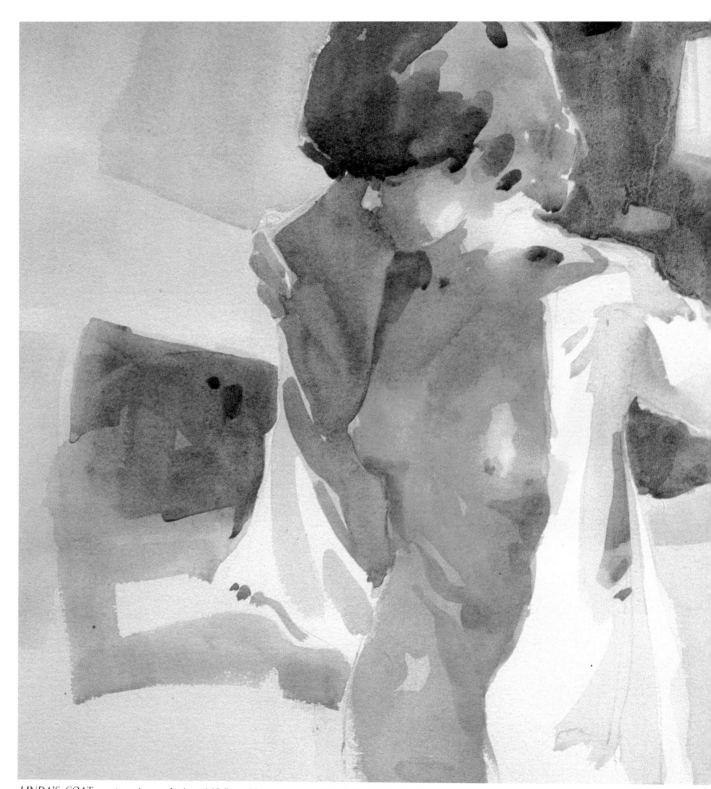

LINDA'S COAT, watercolor on Arches 140 lb. cold-press paper, 18" x 22" (45.7 x 55.9 cm).

This painting was done several years ago; it is my oldest surviving figure painting. Though it may be lacking in some areas of concern, I do look with some pride at the placement, interest, and organization of the negative shapes that balance the page.

LOST AND FOUND

More than painters of any other subject I've seen, it seems that figure painters have a tendency to divide the painting into two totally separate parts—the main subject (the figure) and the background. This can be visually disturbing if there is no relationship or unity between these two separate parts. We need to develop some bond between these elements so we can get into the figure from the background and into the background from the figure. If this isn't done, the figure will look like it was cut out and pasted over the background. In effect, it will seem like two artists, one a figure painter and the other a background painter, worked independently on the painting.

In the past, we were taught to begin a painting by making a line drawing of our subject and then painting within the boundaries of the lines. However, because we want to create unity between our figure and background, we will now begin by purposely painting through many of the lines of the drawing in order to allow color and value to merge areas of the background and figure together in the beginning stages of the painting.

In the chapter on linkage, we defined "passage" as a creative pathway that bridges separate forms within the figure. Passage allows the eye to travel across shapes without being visually stopped at the edge of each separate shape. Now let's employ this concept of passage to create unity among not just the shapes of the figure but the shapes within the entire painting.

By creating passage, we develop relationships between the figure and background early in the painting process. In effect, we are beginning the painting by creating mostly lost areas or out-of-focus shapes before gradually bringing the subject (or as much of it as we feel is necessary) into focus, while allowing many areas that do not need explanation to remain lost or out of focus. Obviously, wherever the spotlight hits the form of the figure, the shapes will be sharp and in focus,

and wherever the shadow exists, the form will be a little less defined. However, it is also up to the artist to decide where it is better to display the form in focus and where it is better to leave the form undefined. It makes sense to keep the areas of the figure that are attractive or interesting in focus and allow the bothersome, busy, or less important shapes to become lost or out of focus.

Learn the language of the unsaid, the poetry of the unexplained. Realize the excitement and interest created when some of the painting is left to be interpreted by the viewer. Rather than giving the complete story, we create lost-and-found passages that are filled in by each viewer in a personal way. Every person who views the painting will have a different reaction to the work. The more we allow the viewers to exercise their perception of what the painting is, what their interpretation of the subject is, the more enjoyable the painting is to the audience.

I think we have an obligation to the viewer. Much is said about the artist fulfilling his or her own needs when creating a painting, and certainly this is valid. But if we expect to have an audience for our work, we must consider their needs as well. What artist paints for himself to the extent that he is willing to destroy the work upon its completion? I think most of us want our work to be viewed and enjoyed by others. We have an opportunity to share the pleasure that painting provides.

When the painting is totally explained, a viewer might look at the painting once or twice—admire the technical handling, perhaps—but will soon lose interest because the story has been completely told by the artist. The viewer isn't allowed to participate. On the other hand, if the artist leaves some of the painting unexplained, the viewer is invited to look closer, to use his or her imagination, to discover and interpret in his or her own personal way.

The first stage of the lost and found demonstration is begun by drawing an image of the model on my watercolor paper. Since I know I'll be applying several fairly strong transparent washes over this drawing, I go back and firm up the lines so the image will be readable through the paint. The color choices I'll be making in this demonstration are to be considered not as right answers but only as possibilities.

I begin my painting by mixing a very liberal amount of manganese blue in my palette mixing tray. With my two-inch (5 cm) flat brush, I apply a light-valued wash that covers the entire page, with the exception of a few accents of white paper that I simply paint around. Except for the saved accents of white, I am unconcerned with any development of subject matter. I want to create some variety in this cool wash, so once the page is covered with manganese blue, I introduce cobalt violet and ultramarine blue to the wash. In effect, I'm beginning the painting by painting the "lost" areas, which will ultimately become avenues of passage in some parts of the painting. The overall idea here is to begin the painting extremely out of focus and then gradually bring the subject matter into focus.

Once the page is covered with a variety of cool washes, I clean my brush and tray and immediately mix a warm puddle of aureolin yellow and alizarin crimson. (We'll be discussing reasons for developing color temperatures shortly, but for now let's just say I'm adding the warm, fleshlike mixture of paint over the cool wash so that the image of the figure will read as a mostly warm flesh tone.) I apply this warm mixture over the area of the still-wet page where the model is located, but I allow it to be found in part of the background as well. I reach back into my cobalt vio-let and add another layer to the midsection of the figure, allowing this wash to continue out into the background on the bottom right of the page. I'm thinking at this point that the form will probably be found, or brought into focus, to a great extent on the upper left side of the figure, where the saved white is. I will therefore probably allow the lower right side of the figure to remain lost to some degree. Notice that even though I have introduced several washes on the page at this point, the drawing can still be seen. I'll stop here to allow the washes to dry.

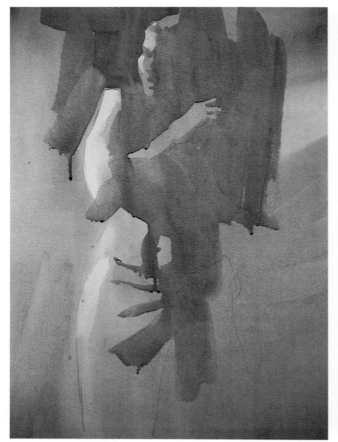 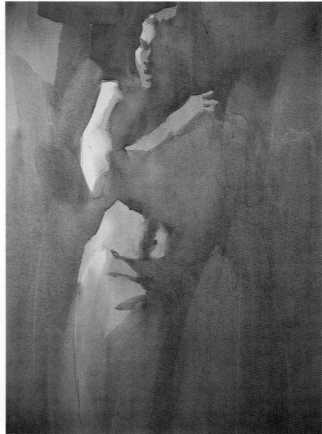

Once the page has dried, I mix a middle value of ultramarine blue and begin to find the figure just a bit more by painting around a few edges of the form. For instance, the arm and hand that cross the torso are brought into focus. At this point, the idea is to sneak up on the figure, so to speak, rather than just cutting out all the shapes, so, I allow this wash to weave into the background from the figure and into the figure from the background.

I clean my brush and tray again, then mix a middle value of vermilion, alizarin crimson, and raw sienna to add more of a feeling of warm flesh to the figure. I apply this mixture immediately, starting at the head and allowing the warm wash to flow down and over a good portion of the figure. I also allow some of this warm color to flow from the figure out into the background. I rewet the background areas by applying a liberal amount of cobalt violet wash over the mostly ultramarine blue areas, softening the hard edges in the background that were made by the preceding wash. Again, I pause to allow the painting to dry.

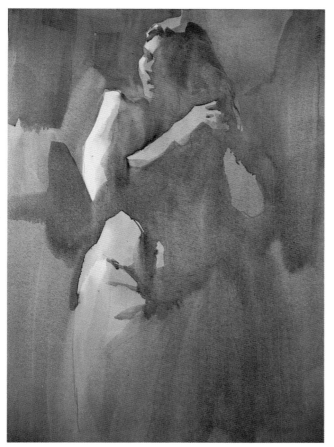
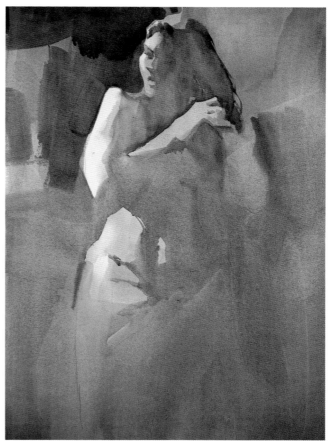

Once the painting has dried, I paint back into the figure with alternating cool and warm washes to again bring a little more subject matter into focus. For instance, the back of the head and the elbow on the right are found to some degree. I'm stepping back a lot to continually try to get an overall view of the work in progress. I'm cautious here not to allow any part to become too detailed, though I know a little more information is needed. My pace slows, and I spend more time looking than painting.

This stage is actually a continuation of the last one. Rather than stopping and allowing the painting to dry, I continue to rearrange the shapes and interest within the painting, working directly into the somewhat wet pigment. I find that pigment is very adjustable in this damp stage, so it's easier to make changes. For instance, I feel the cool shape on the left side of the painting, by the model's elbow, is a bit too demanding, so I relax it by painting over it with another wash; the shape loses most of its form. (Compare this area with the previous stage.) I want to develop a little more impact with the shapes at upper left, and I also feel the need to stretch the value now, so I introduce a fairly strong dark in the top left of the painting. Though I'm now in the later stages of the painting and I'm working with darker values, I continue to keep the big brushes involved. Again, I pause and step back to get an overall view but do not allow the pigment to dry.

I had felt that the large darks placed at the upper left of the figure worked well to show off the forms and lights on the model's face, shoulder, and left arm, but when I step back to get an overall view, it is obvious that the size and strong value of these background darks make the overall painting appear out of balance. Do you agree? I want this dark area to stay, so rather than washing it off, I simply add a counterbalance of shape and dark value on the right. I jog the position of this added shape so that it will balance without being predictable or visually equal.

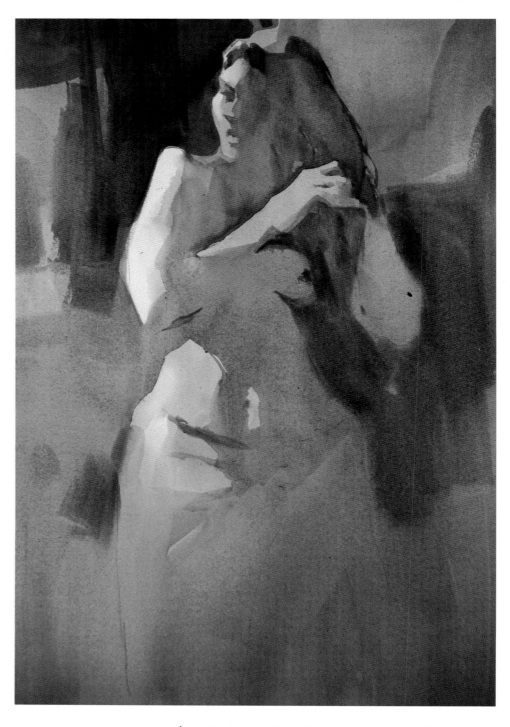

In the final stage of the painting, a few accents of color, shape, and light are added to bring the painting to completion. However, notice that much of the information about the figure is only hinted at or left unsaid. I've tried to continually create and save avenues of passage throughout the figure so that the viewer's eye can easily move in and out of the various shapes and forms. Notice that the shadow just under the model's left arm continues right out into the background, and though her skirt is evident where it is found by the light, it is allowed to escape completely in the shadow pattern on the right.

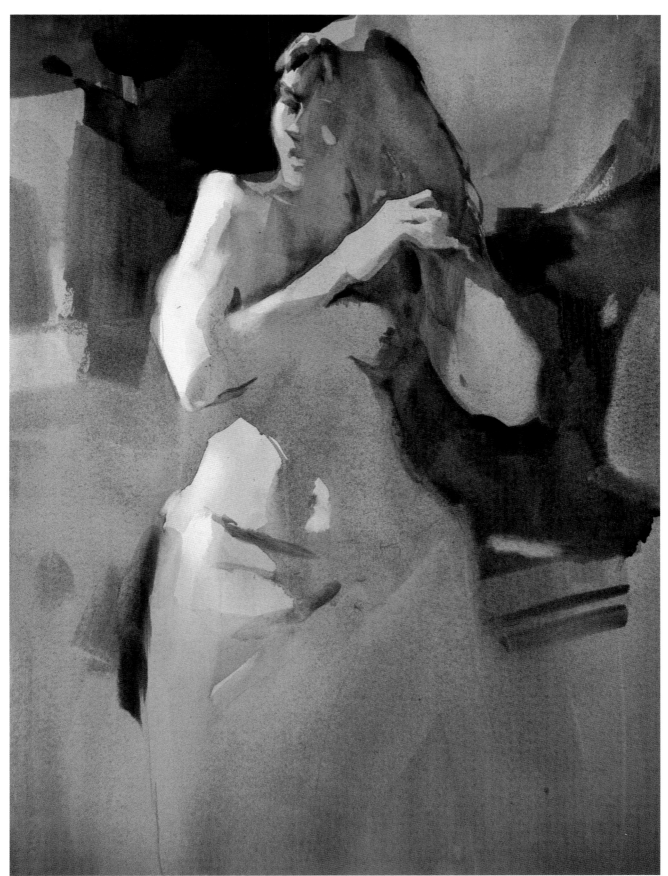

BRENDA, watercolor on Arches cold-press paper, 22" x 30" (55.9 x 76.2 cm).

LESS IS MORE

In figure class, one of the most common problems I see in other artists' work, as well as my own, is painting in too much information about the subject. We must first realize that the human form is filled with information from head to toe. Every square inch has some change in shape, some interest or detail. The goal in most of my paintings seems to be, "How can I tell LESS about the subject?" not "How can I explain more?" Less *is* more.

When the model poses under a spotlight, there will be many interesting areas of shapes and light across the face and body. Every detail will compete for your attention. And you must decide which is the most important or exciting shape or light to accentuate, then push back or eliminate the other competitors. You must become aware of how much detail is visually necessary to make the painting work—not how much is actually there, but how much is needed. Generally, a good part of the figure will need to be calmed down or left a little unexplained so you can more clearly show off the few balanced exciting areas of form or light you feel are worth accentuating.

In a particular pose, there may well be a wonder-ful pattern of light flowing across the form of the figure. This light accents the bridge of the nose, the side of the face, and the hair but is just as dramatically found on the arms and chest, as well as the hands, legs, and feet. It becomes our job as artists to pick and choose where the excitement will be enhanced in our painting, and just as important, where it will be subdued.

Develop your painting in much the same way a writer develops the characters in a book or play. There are usually just a few main characters around whom the story revolves. Then there are a few secondary characters who have some interest but support the main characters; and finally, there might be several minor characters who have only a line or two of dialogue.

Step back and evaluate your paintings in these terms. Don't say, "Did I record every detail of the figure correctly?" Instead say, "Can I easily recognize a few dominant focal points or main characters? Are there a few areas of secondary interest and some noncompetitive subordinate areas in the painting that don't steal the interest from the main characters?"

We develop detail or interest in a watercolor painting by creating small, active shapes, or calligraphy. The inexperienced painter might therefore assume that the more detail or interest a painting contains the more exciting it will become. Unfortunately, most of the time just the opposite result is produced. Small, active shapes are interesting in themselves, but they can also be very demanding. In effect, each detail calls for the viewer to "look at me." In this example, I created interest in the painting by developing small, linear lights on the model where the spotlight hit. Rather than being selective, I simply reported the light where it was found on the form. When we examine each part of the figure separately, the light is interesting; however, when we step back and look at the figure as a unit, we are somewhat overwhelmed by the activity of the light, which seems equally important throughout. In effect, each special character of light calls for us to "look at me."

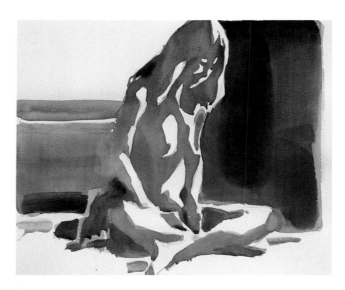

In this positive example, I repainted the pose again as closely as possible, except here I was selective as to what characters of interest (the lights) would be shown off, and I eliminated the competitive light. One of the hardest things an artist must learn is to paint out exciting details that are beautiful in themselves, for the sake of the overall balance of interest in the painting. As hard as this was for me to do, I realized that it was necessary here, so I cut away most of the activity of linear light to create a more unified balance of interest.

I enjoyed the special qualities of light, color, and simple balance of shapes in the demonstration, and I felt compelled to get out a full sheet and see if these qualities might again be captured in a finished painting. I tried to work quickly and not be enticed into saving more details on the full-sheet painting than were absolutely necessary to excite the page. The goal continues to be "how can I tell less, not more?"

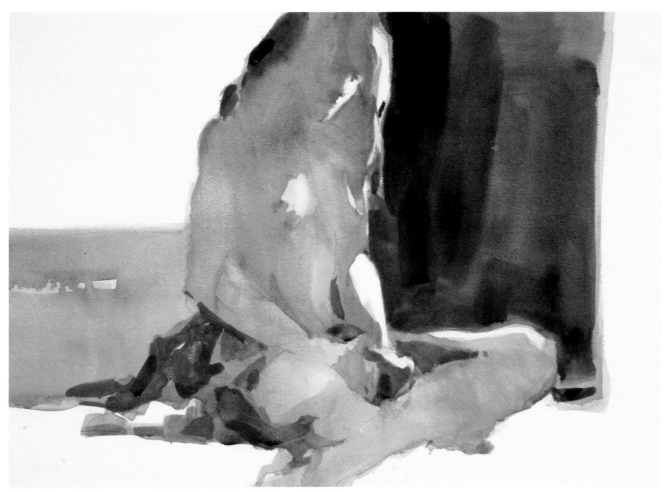

CAROLYN, watercolor on Arches 140 lb. cold-press paper, 22" x 30" (55.9 x 76.2 cm).

EDGE QUALITY

The artist can say a great deal about how the shapes within the figure are constructed and how they turn and change by manipulating the edges or edge quality of these shapes.

When I first paint in the linkage of the shadow pattern across the figure, I use hard-edged patterns and keep the edges of all shadow patterns constant. A hard-edged pattern separates light from shadow, much like a scissor cutout. In effect, I am defining the shapes within the figure as totally in light or totally in shadow.

By softening the edges where the shapes gradually change from light to shadow, we are able to describe these shapes with more understanding and depict more convincingly how some shapes within the figure are rounded as they turn away from the light. As I have said, I generally first paint in the shadow patterns in a hard-edged cutout fashion. Then, to soften or relax some of these edges, I rinse my brush to clean out the pigment and then pull the brush gently through a tissue that I constantly hold in my hand as I paint. I want the brush to be damp but not dripping with water. Then I touch back into the edge of the shape with the point of the brush and gently pick up the wet pigment on the edge of the shape. I try to lift the right amount of pigment on the first attempt, but sometimes I have to go back and lift again. If the brush is a little too wet, the pigment will wash back into the damp edge of the area being softened. On the other hand, if the brush is too dry, the pigment on the edge of the shape will not be picked up. After you experiment a few times, you will begin to get a feel for how damp your brush should be. You'll also find it much easier to relax and pick up pigment if you do so before the shape has had a chance to dry on the page.

Throughout the figure you will find an endless variety of edges that describe the shapes of the body. Edge quality varies from a sharp razor edge of light against dark to a gradual rounding from light to dark, with many variations in between. Just remember: The more abrupt the change from light to dark, the more angular the shape will appear. The more gradual the change from light to dark, the softer and rounder the shape will appear.

When I apply paint to the dry surface of watercolor paper, the edges of the shape I create appear hard, flat, and in focus.

To develop variation in the edge of the shape, I clean my brush of pigment, pull it through a tissue to remove excess water, then touch it back into the edge to lightly pick up the pigment.

Immediately, I gently touch back into the softened edge with a tissue to dry the area and also pick up any excess pigment left by the brush.

Throughout the planes of the figure, edges describe the form by the way they turn from light to shadow. Use this technique of edge relaxation to imply the softening of forms where it occurs in your painting.

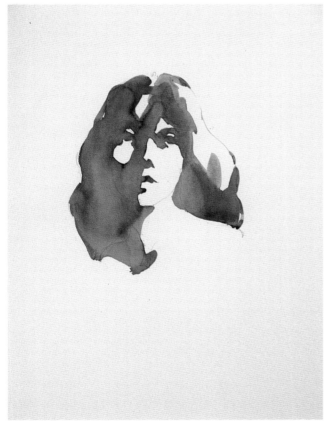 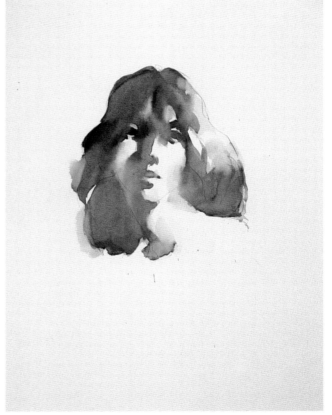

When first painting the linkage of shadow, I generally create a hard-edged pattern much like a wood-block print or a cutout. This hard-edged pattern seems to indicate that all the edges of shadow turn sharply from the light. In effect, form is described as totally in light or shadow.

While the pigment of the shadow pattern is still damp, I reached back into the hard edges with a pointed brush to soften some of them. This relaxation of hard-edged shapes seems to give a more honest explanation of how many of the shapes found on the face are more rounded as they gradually turn from light to shadow.

DESCRIBING EDGE QUALITY

Just as hard-edged or cutout shapes benefit from some softening, so too do soft-edged shapes benefit from some firming up.

If all the edges within a form are soft and diffused, the form will appear symmetrically rounded, like the tin can in illustration A, which appears to be round because the light side gradually turns to shadow. Though we sometimes might think that arms and legs are evenly rounded, similar to a cylinder or pipe, nothing could be further from the truth. To gain a more accurate understanding of how these limbs are actually shaped and how they can best be described, let's give the tin can in our illustration a good squeeze. Now look at the shapes that appear within the borders of the can (B). Notice that there are some hard edges where the dents turn sharply from light to shadow. Some edges are semi-angular in form, while others appear soft or rounded.

Now look at the example of the arm (C) and observe the same variety of edges, from soft and rounded to hard-edged and angular, created by the bones and muscles within the arm.

Of course these changes of edge quality are found throughout the figure, and by looking for and discovering as much variety as possible in these edges, we are able to give a more precise description of how the shapes are formed within the figure.

A B

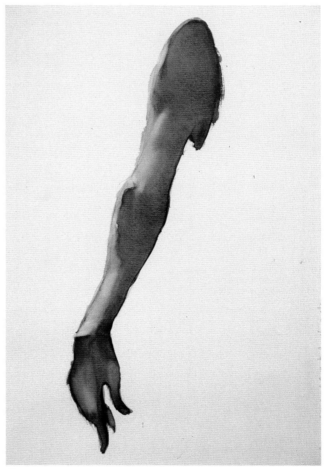

C

EDGE QUALITY: VARIETY

Aside from enabling the artist to describe more accurately how the shapes within the figure are constructed, adjusting the edge quality of these shapes also gives the artist an opportunity to create and develop contrasting edges for the sake of variety. We can balance hard edges against diffused rounded ones, making both edge qualities more exciting and unique. Crisp edges that somewhere become relaxed, or in-focus forms that sneak away, add a poetic quality to the artist's interpretation of shapes. Variety is a valid reason to adjust edge quality. So feel free to develop hard and soft edges, not only where they are found anatomically but also where you, the artist, would like them to be.

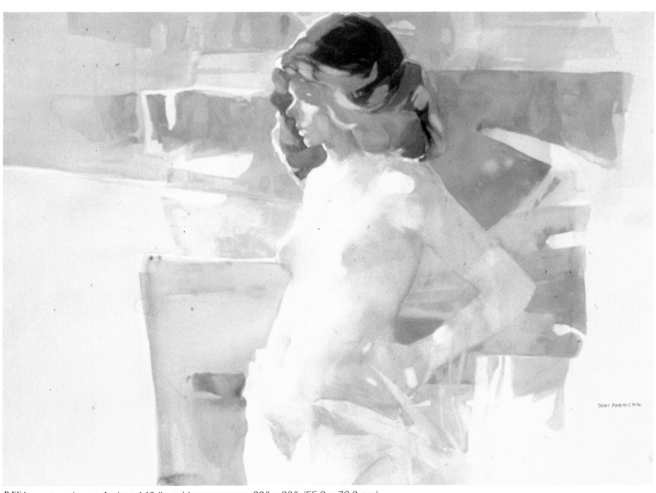

RITA, watercolor on Arches 140 lb. cold-press paper, 22" x 30" (55.9 x 76.2 cm).

The harder and softer edges within the shapes of the figure and background express how the forms are affected by the light and shadow. In this painting, compare the soft edges within the model's torso, which suggest rounded or soft shapes, to the somewhat dramatic hard edges in the face, hair, and shoulder, which make them appear more angular. This contrast in edge quality not only expresses vividly how the various shapes are formed but also adds variety to the painting. For instance, notice that the shapes in the background are also developed with a varying degree of hard to soft edges. I arranged these edges this way to add interest to the background shapes.

BACK LIGHT, watercolor on Arches 140 lb. cold-press paper, 22" x 30" (55.9 x 76.2 cm).

As the model posed with her back to the light, the many structural changes that occur in the back, ribs, and hips were dramatized by angular shapes with hard edges where they turned away from the light. To offset this hard-edged quality, I allowed many of the shapes in the shadow of the figure and in the background to have soft edges and become lost to a great degree. The idea is to express the edge qualities the model's form provides where they are necessary to explain the pose but also to develop edge quality where it is needed aesthetically to create balance through contrasting edge qualities.

COLOR

Early on in my painting experience, color seemed like such a struggle. I believed that my problems with color derived from a lack of formal education, and I assumed that, at some point in my future, I would learn color formulas, and when I mixed the correct formulas of various colors and applied them to my paintings, my paintings would become colorful. In art school, I quickly learned concepts of color development using the color wheel and read about color theory from the masters. But still my paintings turned out somewhere between army green and muddy gray.

It seems funny to think that the colors on my palette today are pretty much the same as in those early days. Today one of the most enjoyable aspects of painting for me is the fun of finding exciting color. Color is a wonderful means of showing your personality and expressing your feelings about your work. I have come to believe, through years of trial and error, that the "special" color in a painting must be searched for and rediscovered in each new attempt. We must learn to trust our taste and follow our feelings rather than depend on the predictability of a color formula.

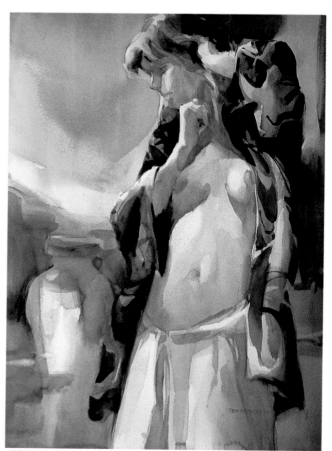

Rather than beginning each new painting with a predictable formula that has worked well in the past, I try to constantly search for new answers to what the possibilities for exciting color can be.

LYNN, watercolor on Arches 140 lb. cold-press paper, 22" x 30" (55.9 x 76.2 cm).

GRANULATION

For many years I painted watercolor on a flat, horizontal surface. This seemed to be the obvious and the only way to control the medium. After all, when you put a color or shape down, it stayed where you put it. The puddles of wet pigment didn't run and eventually dried in place. The colors in my paintings were confined to the colors on my palette and flat intermixings of these palette colors. These pure or palette-mixed colors were delivered to my horizontal watercolor paper and left alone to dry. Like most watercolorists, I was taught to "put it down once and leave it alone." I was warned that if the wet pigment on my paper was touched again, the result would be dull or "muddy" color. I can still hear my early watercolor instructors say "The thing about watercolor is, you have to get it right the first time." The result of painting in this fashion was that the color in my painting was predictable—not creative, but correct.

After many years of painting this way, I had the opportunity to see a watercolor demonstration where the artist tilted his painting board up on an easel at a vertical plane of about seventy-five degrees. Rather than mix all the colors on his palette and then apply the mixed color to the paper, this artist applied pure color directly on the paper, and as the wet pigment gradually moved down the page, the colors actually mixed themselves directly on the paper surface. Thus, in effect, the artist mixed color directly on the watercolor paper itself rather than on the palette. The resulting mixed colors were glowing and luminous, even after being painted into and changed many times. Also, the artist wasn't confined to the tube colors or flat mixtures on his palette but could explore the endless combinations and intermixings of colors created by the blending of paint on the paper. As one wash of wet pigment was applied over another, the resulting colors became more and more luminous. This process of wet-into-wet color mixing is called "granulation."

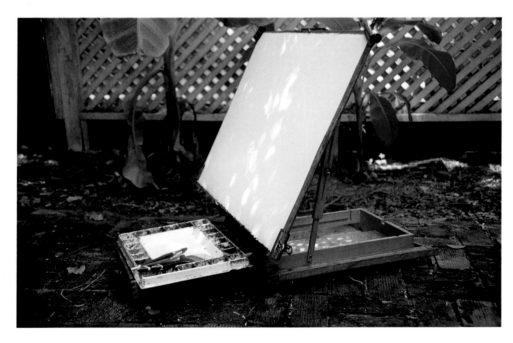

There isn't a correct angle to slant your paint board in order to create granulation with watercolor pigment. Just remember, the more vertical your painting surface, the more dramatically the pigment will granulate down the page. You should experiment to find the angle that works best for you. This photo shows the angle I generally use (about seventy-five degrees).

GRANULATION EXERCISE

To gain a better understanding of the unique and exciting possibilities of granulation with watercolor, let's try a simple experiment to compare granulated color with color mixed on the palette. We'll begin by giving ourselves the goal of mixing a flesh tone. With this in mind, take a half sheet of watercolor paper and draw two 8″ x 10″ (20.3 x 25.4 cm) rectangles. Clip your paper to a paint board and lay your board flat on a table or floor. Make a flesh tone in your palette mixing tray by combining raw sienna with a little alizarin crimson. Now load your one-and-a-half-inch or two-inch flat brush with this mixed color, deliver it to one rectangle on your paper, and allow the paint to dry (A).

Now let's try creating the same flesh tone with granulation. First, tilt your paint board up at an angle of about seventy-five degrees. (I use a French easel.) Using the same large flat brush, mix a puddle of cerulean blue in your palette mixing tray and, making side-to-side strokes, starting at the top and moving down, cover the remaining rectangle on your paper (B). Allow each brushstroke to begin at the bottom of the preceding one so that the page is evenly covered with as few strokes as possible.

Now clean your brush and palette and immediately make a puddle of cobalt violet in your mixing tray. (Let me emphasize again that the color choices in this experiment are just possibilities.) Load your brush and, starting at the top of the still-wet cerulean blue rectangle, repeat the side-to-side paint strokes right over the cerulean blue pigment (C). Some bothersome streaks may appear at first, but they'll quickly disappear as the colors mingle. Clean your

palette and brush again and make a puddle of sap green. Load the brush and repeat the process of side-to-side delivery of this pigment over the still-wet mixture in the rectangle (D). Next, try manganese blue, repeating the painting process again (E). Notice that each time a new color is introduced, it becomes the dominant color as it is laid on top of the preceding mixture.

Finally, mix a flesh tone in your palette mixing tray by again combining raw sienna and alizarin crimson. As before, start at the top of the rectangle and paint with side-to-side strokes (F).

Now put the brush down, step back, and compare the two rectangles of painted flesh tones. They both achieve our stated goal of reporting flesh well enough, but that is where the similarity ends. The first rectangle of flesh tone that was "put down once and left alone" has no personality. It just sits on the paper surface in a flat, two-dimensional way. The granulated rectangle of flesh tone, however, seems to be luminous and glowing. There is a richness and depth to the paint quality. Both rectangles visually explain the color of flesh, but which quality of paint do you prefer?

This method of developing paint quality through granulation is really a simple one, but if you are new to the concept you will have to make a few attempts before you catch on to the mechanics of it. Of course, it's impossible to explain in writing how much water or pigment is used or how heavy or light the brushstrokes should be. It's something that must be experimented with. Like most things, it's easy once you get the hang of it.

Don't just try it once and say, "That didn't work for me." Critique your painting rectangles. If your painting dried light and was so watery that when you applied one wash over another you washed off the preceding color, then adjust the amount of pigment by using a little less water and try the exercise again. On the other hand, if your brushstrokes were extremely streaky and too thick to mingle downward or granulate, perhaps you need to add a little more water to your color mixture.

Just remember that this method of granulating color can be developed using any number or combination of colors. The point to keep in mind is that the last color introduced will generally dominate.

A

B

C

D

E

F

COLOR TEMPERATURE

One of the best ways to turn on or excite the color in a painting is to use contrasting color temperatures.

It seems we can more vividly describe the temperature of a color theme in a painting by not only building a range of colors in the same temperature but also giving a taste of the opposite color temperature. Simply stated, a touch of cool color "turns on" a predominately warm scene, and a touch of warmth enlivens a predominately cool scene. In effect, what we're doing is giving a visual description of the opposite temperature so we can more emphatically convey the dominant color temperature of a painting. This concept reminds me of the old saying "If you want to look good, stand next to someone who doesn't." Just as a good sad movie has a touch of comic relief to stretch the audience's emotions, use contrasting temperatures to stretch the emotions of your painting.

The color chart I have developed is pushed in an obvious cool temperature direction. I have stated what "cool" is in an honest, matter-of-fact manner by reaching into a little of each of the blues on my palette. Though the chart is obviously not lacking in color explanation, it does seem to be lacking in color excitement.

In this example, I have again developed a color chart that is obviously pushed in a cool direction. However, in addition to visually explaining what cool color is, I have also given a hint of what it isn't. This contrasting warm color is kept in the minority and is overpowered by the cool colors, so the chart remains a statement of cool colors; however, the visual hint of warm contrast enlivens the cool colors and more emphatically expresses the cool dominants.

This concept of enlivening color by creating visual temperature contrast applies to the warm colors on my palette as well. Again, I began by developing a color dominance, this time using the warm colors on my palette to make a statement about what warm-temperature colors are.

Once again I have constructed a warm color-temperature chart, but here I added a contrasting hint of cool relief to give the viewer a visual explanation of the opposite color temperature. The chart remains dominantly warm, and the warm temperature becomes more vividly expressed by the contrasting hint of cool pigment.

Now let's apply this concept to the figure to see if we can excite the warmth of flesh through the use of temperature contrast. In the first example, I constructed the figure by reporting flesh as I actually saw it, using the warmth of tan, pink, and sienna. The flesh is technically correct but overly warm and unexciting.

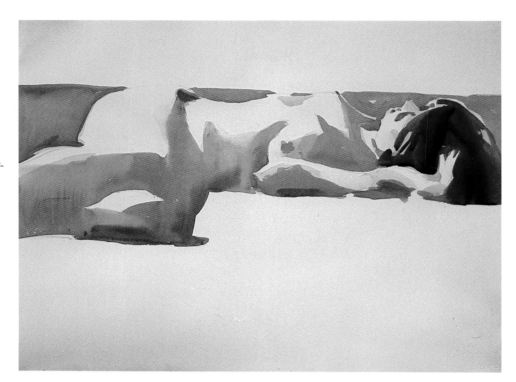

Realizing that I wanted to excite the warmth of flesh, I began this example by painting the shapes with the opposite or contrasting color temperature of cool pigments. I cleaned my brush and palette and then introduced the colors of warm flesh over the underlying cool paint. Because the warm flesh tones are lying on top of the cool, the warm colors dominate. I was careful to save hints of pure cool or mostly cool pigment to increase the visual contrast, and to make the warm flesh come alive. I also developed areas, such as the background and model's hair, that are intermixings of warm and cool pigment. They become a neutral bridge between the two contrasting temperatures.

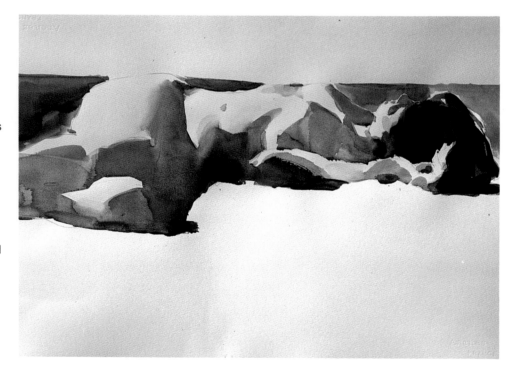

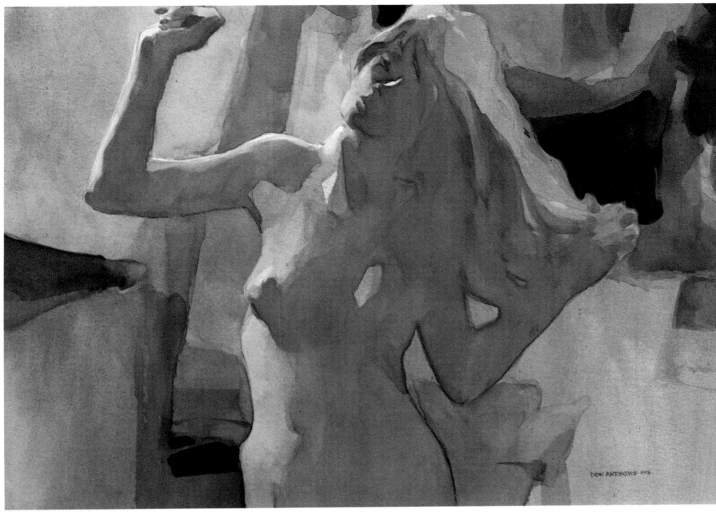

ANGELA, watercolor on Arches 140 lb. cold-press paper, 22" x 30" (55.9 x 76.2 cm).

To visually express the feeling of living flesh, we usually reach for the warm pigments in our palette. However, it's just as acceptable to develop the impression of living flesh by using the cool side of the palette and employing the warm colors as a relief. In this painting, I first developed areas within the figure and background using warm pigments. Then I quickly overpowered the warm statement with a variety of contrasting cool colors. Care was taken to allow some of the beginning hints of warmth to be saved to provide visual relief from the mostly cool arrangement of color.

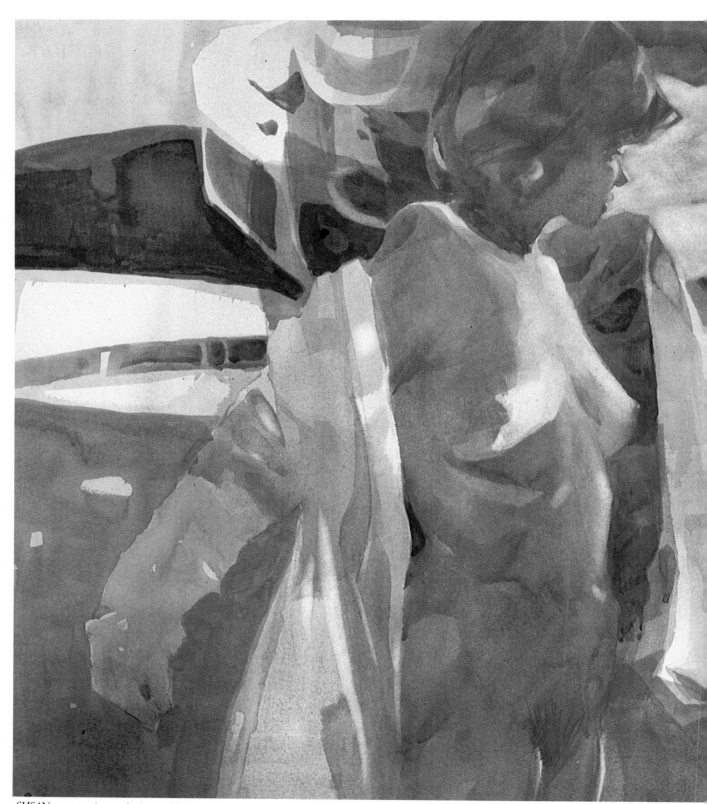

SUSAN, watercolor on Arches cold-press paper, 22" x 30" (55.9 x 76.2 cm).

I love the warmth of tropical colors, and I enjoy discovering the endless variety of directions they offer, but to turn on the excitement that warm pigments can produce, I usually find it necessary to introduce a few contrasting hints of cool relief. In this painting, I tried to turn on the warmth of color by developing as many variations of warm colors on the page as possible. However, only when the contrast of cooler colors was introduced did the warm color in the majority of the painting come to life.

WHAT COLOR IS FLESH?

Whenever I've explained the flesh colors by mixing variations of yellows and reds such as raw sienna and alizarin crimson, I have found that my painted flesh tones are "technically" correct and visually boring.

If we were going out in landscape class to paint a group of trees, we wouldn't bring along just a few tubes of green paint. As artists, we feel the need to create and add variety to the local colors of nature. This artistic license applies to figure painting as well.

Technically, it's true that the stronger the light that warms an object, the cooler its shadow becomes. So, technically, the flesh tones of a model posing under a spotlight are warm where the light hits, then the shadows or absence of light on the model will be cooler by contrast. To an artist, however, these technical facts don't seem to be valid reasons to mix only certain colors. I demand the freedom to be creative in my color choices rather than simply observing and report-

manganese blue,
lemon yellow, opera

Hooker's green,
raw sienna, opera

manganese blue,
opera, raw sienna

peacock blue,
alizarin crimson,
aureolin

manganese blue,
raw sienna, opera

cerulean blue,
cobalt violet,
cadmium red
medium, aureolin

turquoise,
lemon yellow,
alizarin crimson,
raw sienna

cobalt violet,
manganese blue,
lemon yellow, opera

ing facts. Instead of painting all of the lights on the model warm and all the shadows cool, I feel the need to place these colors throughout the figure as my taste dictates. By using the granulation method, I can easily add endless variety to the flesh tones and still indicate that the colors represent flesh.

We can begin painting flesh with blues, greens, violets. We can go miles away from the reality of flesh with creative color mixtures, and then, by touching back into these "dishonest" colors with some hints of warm flesh tones, we can usually make these creative colors read as flesh. Not only are we able to accept these created colors as flesh, but the flesh seems to come alive on the watercolor paper.

Again, the examples given are just representative of the possibilities; they are not formulas to remember. Allow your search for creative flesh tones to grow out of these few examples.

ultramarine blue,
cobalt violet,
cadmium yellow,
medium alizarin crimson

aureolin, opera

raw sienna,
manganese blue,
alizarin crimson

cadmium red medium,
cerulean blue,
lemon yellow,
alizarin crimson

cadmium yellow
medium, turquoise,
alizarin crimson,
raw sienna

sap green, turquoise,
alizarin crimson,
raw sienna

To develop visual contrast, in most of the examples I have either started the color swatches with cool pigment or introduced it at some point. The concept to remember here is that any color or combination of colors or temperatures can be introduced, and as long as the warm mixture of a flesh tone is then applied on top, the warm flesh tone will dominate, giving the impression of flesh.

GRANULATION AND COLOR TEMPERATURE APPLICATIONS

Now I'll do a painting to show how these concepts of granulation and contrasting color temperatures might be applied to a figure.

My first step is to develop a drawing on my paper, a 22" x 30" (55.9 x 76.2 cm) sheet of Arches cold-press, then go back and restate or strengthen the lines; I will be applying several washes over the drawing, and I want it to remain readable through the oncoming transparent washes.

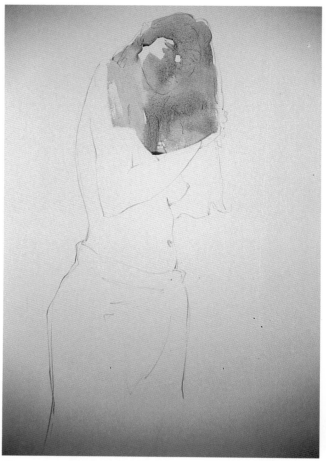

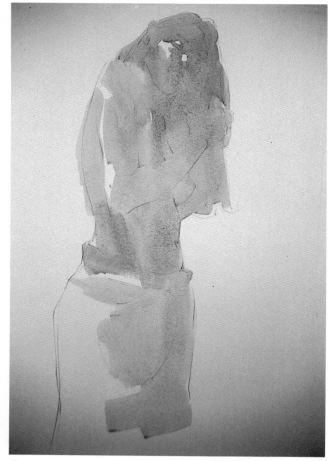

Since I want the figure to ultimately indicate warm flesh tones, I'll start by painting in a light wash of manganese blue, a contrasting cool color. I start at the top of the page and allow the pigment to granulate down the paper. I'm not concerned with developing any structure within the boundaries of the figure at this point, for a few saved whites on the model's face and back of her arm, which will become the accents of light.

Once the figure is covered with my first layering of cool pigment, I immediately mix a warm flesh tone and begin to apply it over the still-wet cool wash. I continue to be unconcerned with stating form and to allow the pigment to flow over the anatomical parts. In effect, I am not painting parts here; I am painting the linkage of light.

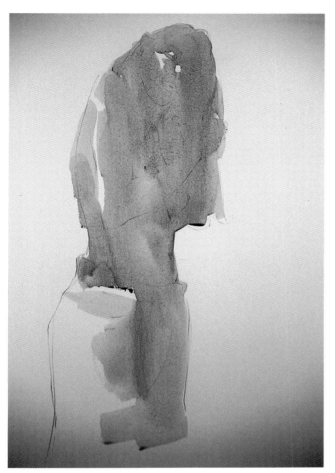

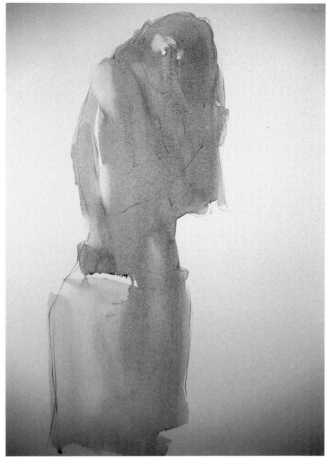

Notice that though I'm beginning to push the flesh back to the warm side, I've allowed some of the cool manganese blue to remain. At this point, I want to create a little variation in color, rather than just warm flesh tones with manganese blue as relief, so I add cobalt violet into the wet pigment; the new color pulls the flesh back to a cooler statement. Notice that when new washes are applied, they are put on top of earlier washes in some areas and placed beside earlier washes in other places. The idea is to create a variety of colors, both warm and cool, within the painting.

Once the cool cobalt violet is introduced, I mix a warm flesh-tone wash and push the flesh in most areas once more to the warm side. I have been applying wash after wash in a wet-into-wet manner up until this point, as I have been concerned with granulation of color rather than finding form within the figure. Now that I have painted in the lights found on the figure, it's time to allow the pigment to dry.

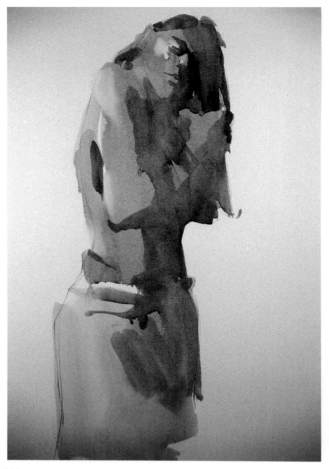 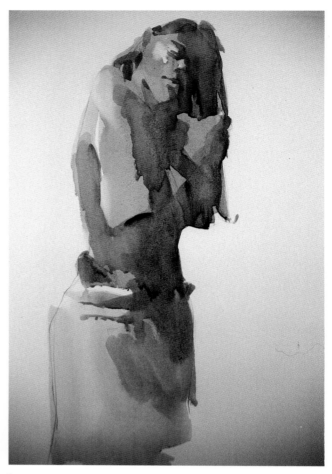

When the pigment has dried, I can turn my attention to developing form within the boundaries of the figure by introducing a shadow pattern. I mix a middle value of ultramarine blue (again beginning with the cool), and starting at the top of the page, I paint a continuous linkage of shadow pattern that cuts around the separate forms of the face and into the torso. Once this is done, I add mixtures of other cool pigments to give variety to the cool wash.

I overpower this cool shadow pattern with a warm flesh tone but again allow some of the cool statement to remain. Deciding where the hints of cool accent will work best is a personal matter, and your decision will be different in each painting, but listen to your tastes and considerations of balance and organization to aid you in discovering where these elements will be most effective on the page.

Though the page is still damp, I now begin to introduce some darks. I am careful here not to paint the hair all dark because it is so on the model; I try to balance the accents of dark value where I feel they are needed. When I step back to take a look, I get the feeling that the cool washes on the model's wrist and stomach are a bit too demanding, so I simply add a warm wash over them. This seems to enliven the area, and so I allow the warm wash to continue to flow down into the model's skirt as well.

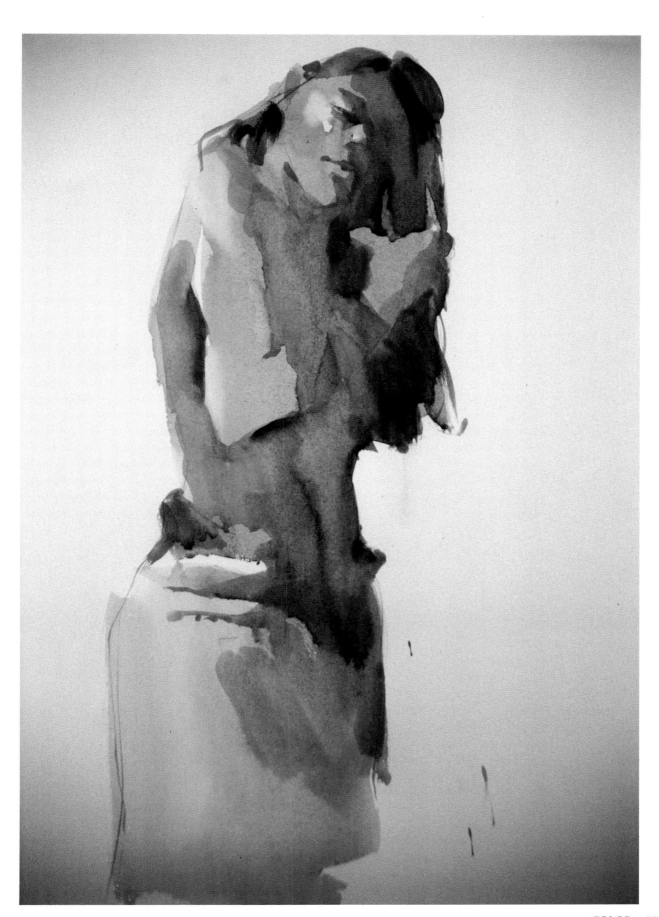

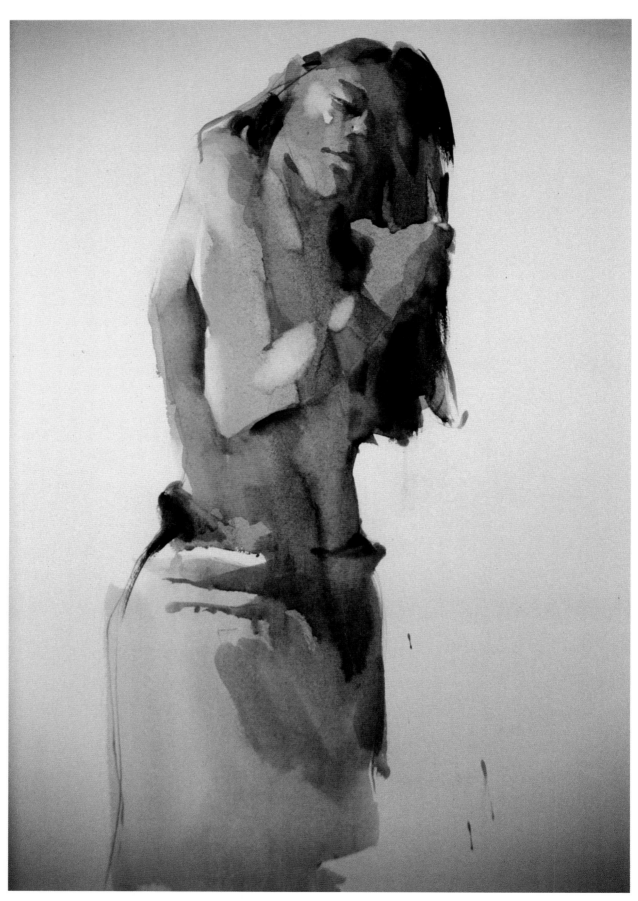

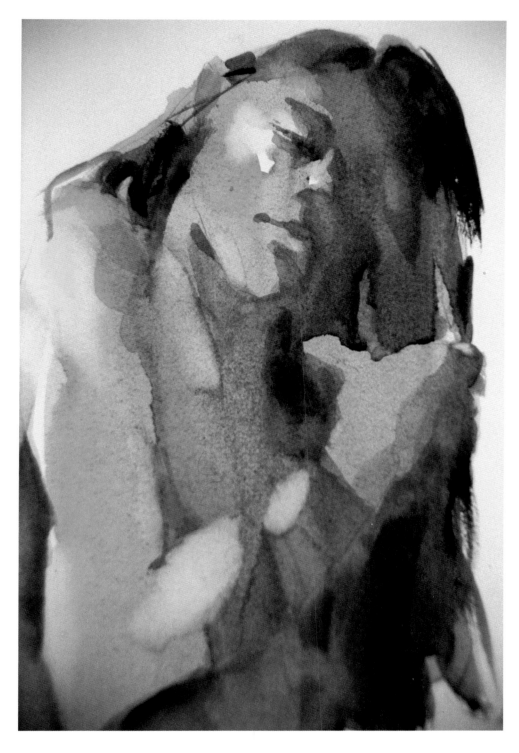

By taking a closer look, we can view the painting not just as a statement about the figure but also as a statement about color granulation and brushstrokes of warm or cool pigment as well. I enjoy leaving many of these somewhat unfinished characteristics in the finished painting as visual testimony that I, the artist, created an image that interpreted reality rather than mirrored it.

In the final stage of the painting, I lift out a few lights where I feel they are necessary, such as on the forearm, by simply rewetting the area with a clean damp brush and lifting the pigment with a tissue. I add a few snaps of pure pigment to accentuate the color (for instance, the touch of pure vermilion where the upper arm bends to the forearm), but I am careful not to add too many of these accents, as each becomes a demanding character. Once this is done, the painting is finished.

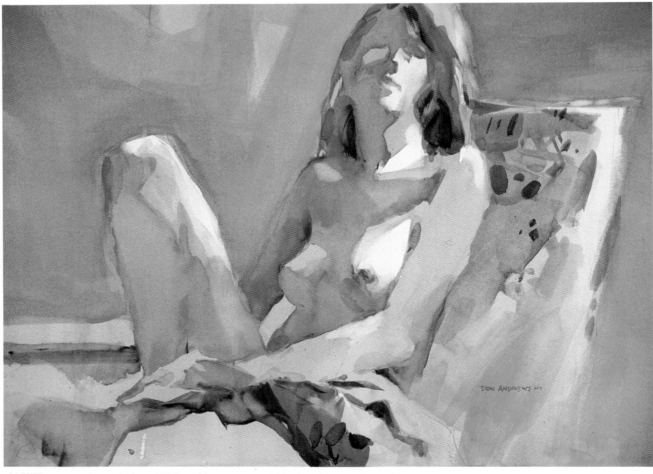

JACKIE, watercolor on Arches 140 lb. cold-press paper, 22" x 30" (55.9 x 76.2 cm).

In this painting, I wanted to create a dramatic statement about warm colors. In order to more vividly suggest the blast of warmth that the yellows, oranges, and reds on my palette can describe, I began the painting with contrasting cool colors. Once they were in place, I overpowered them with stronger warm pigment. Care was taken to occasionally save balanced areas of cool color. This gives the viewer some visual reference to what warm color is by showing a little about what warm colors aren't.

In this painting, the goal was to make a predominantly cool statement yet still describe believable, warm flesh. I began by describing the figure and background with a light wash of warm pigment, then I introduced several variations of cool washes over the underlying warm wash to dominate it. Once this was done, I reemphasized a few warm tones within the boundaries of the figure to develop more of a feeling of warm flesh tones.

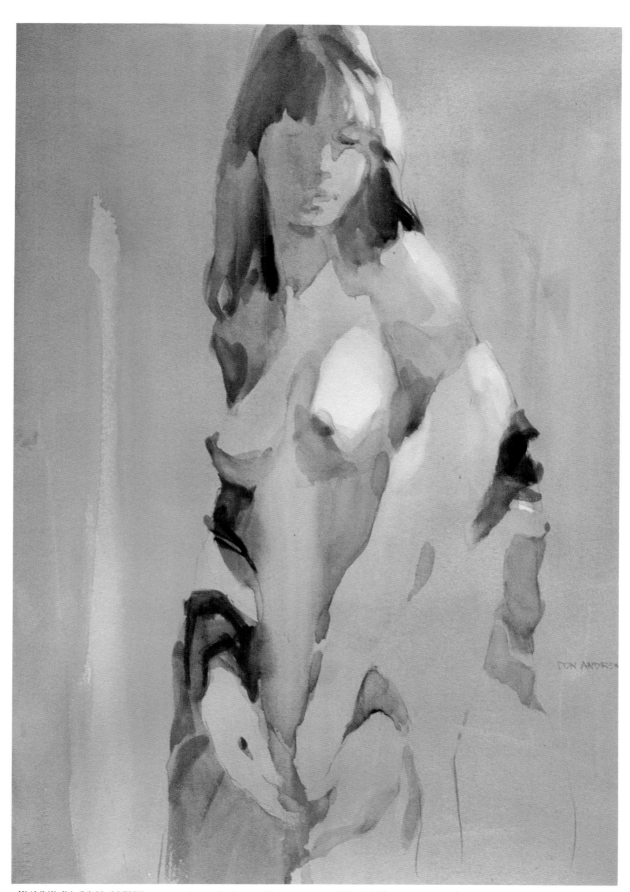

JEANNE IN COOL LIGHT, watercolor on Arches cold-press paper, 22″ x 30″ (55.9 x 76.2 cm).

VALUE

It's hard to discuss color without looking at it in terms of value. It seems most washed-out or colorless paintings fail more from a lack of variety in value than from monotonous color.

We generally begin our paintings with some pretty exciting hints of light, glowing color, but too often, we become timid about dropping down to middle and dark values. In making this statement, I don't want to say that darker-value paintings are better than lighter-value paintings. Certainly there are many examples of successful paintings at both extremes. However, it can be said that most well-structured value plans are built around a range of middle values with the extreme lights and darks becoming the accents of the painting, just as a songwriter takes the vast majority of the notes in a song from the middle range of the keyboard, saving the very highest and lowest notes for special emphasis.

Be aware of what your value tendencies are. Where do most of your paintings stand on the value scale? It seems most of us naturally lean in one value direction or the other. Many of us tend to be delicate painters who barely touch pigment into a loaded brush of water. We always need to reach for the water container to calm down a color before applying it to the page. Most of our mixtures on the palette consist of water with just a hint of pigment. There may be

This painting might be an example of a value plan that is arranged too high on the value scale. Certainly there is some change in value, but the painting is done almost exclusively in the light to light-middle value range. When we reach continually into the water container, we produce the delicacy that watercolor can so beautifully express, but this delicate image can lack backbone. If the value range here describes your work, examine the wells in your palette. Are your colors dabs of dried pigment? If so, squeeze half a tube of paint into each well and add water to keep them moist. Now set a goal to work almost exclusively in darker values.

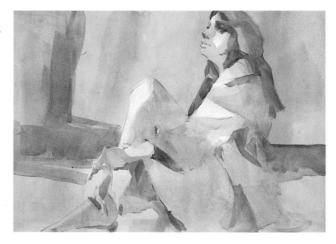

some value changes in our painting, but almost all the values are on the lighter side of middle value. Though we can find examples of successful paintings developed in these lighter values, more often than not the delicacy that we may be striving for appears washed out. The painting seems a bit undecided, lacking character in its tenderness.

So why are we so often stuck on the light side of the value scale? Let's consider a few possible reasons. In most cases, we begin a painting with our largest brushes in our hand and our lightest value on the palette, covering most of the paper with a range of light-value washes. As the painting progresses, we reach for some middle-size brushes as we drop the value down a bit, and toward the finish of the painting, we have our smallest brushes in our hand. That is often when we introduce our darkest values.

Another situation that presents difficulty is the white paper itself. Often I think I'm being bolder than I actually am with my values because all I have to visually compare them with is the white of the watercolor paper. It should be pointed out that watercolor pigment will dry generally 10 to 15 percent lighter than it looks when it is wet. This needs to be compensated for as well.

Another common problem is the habit many watercolorists have of always reaching for the water con-

tainer and adding a full brushload of water to whatever color is being mixed on the palette. Try to be conscious of the amount of water being loaded onto the brush when the pigments are being mixed. If the color appears too watery, add more pigment without going back to the water container.

Some painters tend toward the opposite value extreme. They enjoy the boldness that can be so vividly expressed in a strong watercolor statement, but they seem to jump instantly from the white of the watercolor paper to middle value and beyond. They enjoy the boldness, the power, the blast of color that pure pigment can provide. But often the boldness of value becomes disturbing and moody, gaudy in its purity. Though we can easily see the drama in the values, that drama can quickly become too demanding.

Neither tendency should be considered bad or wrong. Just be aware that whatever you are drawn to or have a feel for, the opposite quality will usually be your weakness. Painters who usually explore the light delicacy of watercolor should do some paintings where boldness of value is their goal. Artists who reach too quickly into the powerful dark-value colors might try a more tender approach for their next few paintings. Neither value plan is better than the other, but by experiencing the opposite range of values, we will begin to develop a more balanced approach.

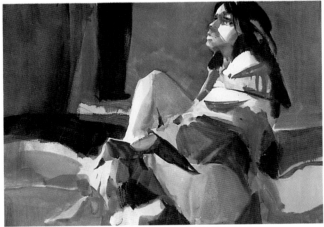

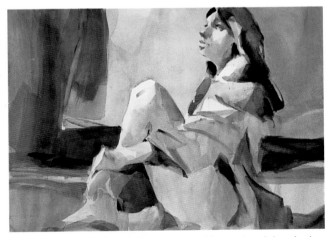

The value plan of this painting might be arranged too low on the value scale. The values lie exclusively in the middle to dark range, with the exception of some whites. When the artist begins a painting with middle-value or pure pigment, the statement created will be dramatic; however, without some relief it will often appear gaudy and overstated. If the value range in this painting describes your work, set a personal goal for the next dozen paintings to work almost exclusively in a range of light to middle values.

The value plan of this painting is structured predominantly in the middle of the value scale. Though this should not be considered the one right answer to what a good value arrangement can be, by stretching out and developing as many stages of value as possible between the extremes of light and dark, we create a visual backdrop for showing off the accents of light and dark.

MIDDLE VALUE

When the value range of a painting is structured to a great degree on a range of middle values, we are able to use value to its fullest potential. The middle of the value range becomes the framework that enables the extremes of light and dark to exist in harmony with each other. In effect, middle values become the bridge from light to dark. Notice that when the majority of the painting is built around middle values, light and dark values become the accents in the painting.

In the following example, be aware that as the value changes from light to middle value to dark, the shapes do not necessarily get smaller. By continuing to use the big brushes we can create scale in a range of middle value and dark as well as light value.

This value chart might be a good indication of a value range found in a normal painting. Certainly this isn't meant to be a rule for every painting but is a general guide to enhance our value concern and awareness. It seems to me that most artists who assume they are poor colorists generally are having more trouble with value choices than color choices.

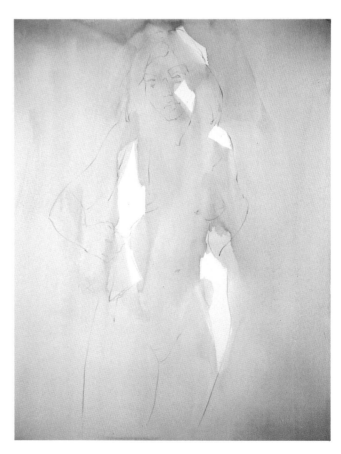

To better demonstrate a painting that revolves around variations of middle value, I'll do a painting where the value is limited to the five values on the scale: light, middle light, middle, middle dark, and dark. I'll use only black pigment so we can more easily look at the painting in terms of value rather than color. The black pigment will, of course, appear as neutral gray tones when diluted with water. I'll also allow the white of the watercolor paper to be the light value in this demonstra-

tion. In the first stage, I make what appears to be a rather bold step down the value scale from the white paper, though in reality I'm not taking nearly as bold a step as we might think at first glance. Experience has taught that comparing any value to white paper will make the value appear stronger. In effect, I've created two values with the first wash. The wash becomes the light-middle value, and the painted-around white paper becomes the light value.

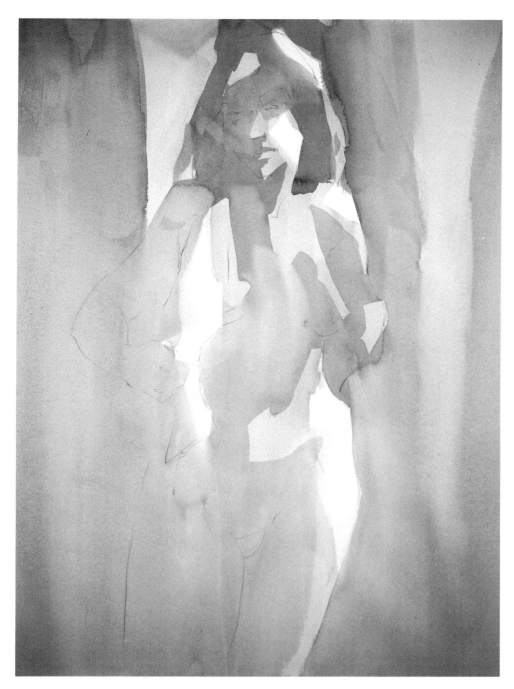

After the light-middle value dries, I reach back into the black pigment and develop a stronger mixture of paint by simply adding less water to the pigment. Remember, this is middle value, so it should be about as close to dark as it is to light. I begin to bring a good bit of the figure into view at this stage, and I continue into the background. I want to cover a good portion of the page here, because middle value, though not as noticeable as the accents of light and dark, is in effect the visual bridge between them. Middle value is the framework that allows the extremes of light and dark to coexist comfortably within the same painting.

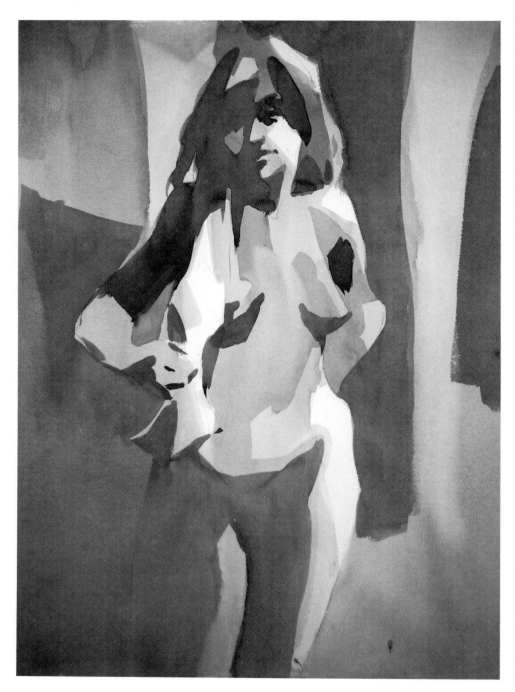

Once the middle-value stage has dried (left); I create a darker mixture of pigment on my palette. To mix this dark-middle value, I must reach deeper into the pigment well and also be a little more aware of how much water is needed. I try to make myself be bold here and see how it pays off. I also keep the big brushes working and continue to cover large areas rather than letting the shapes become detailed or linear.

I step back to evaluate the painting (right) from across the room before I lay in my final accents of dark value (in this case, black pigment). Where will the painting benefit most from a few powerful snaps of dark value? Darks can be small and linear, but I'd also like to discover some scale of medium-size and large as well. Of course, each painting is different, and we can find examples of successful paintings at the extremes of value, but be aware of the possibilities available and the snap that can be created with the lights and darks when most of the value is found in a range of middle values.

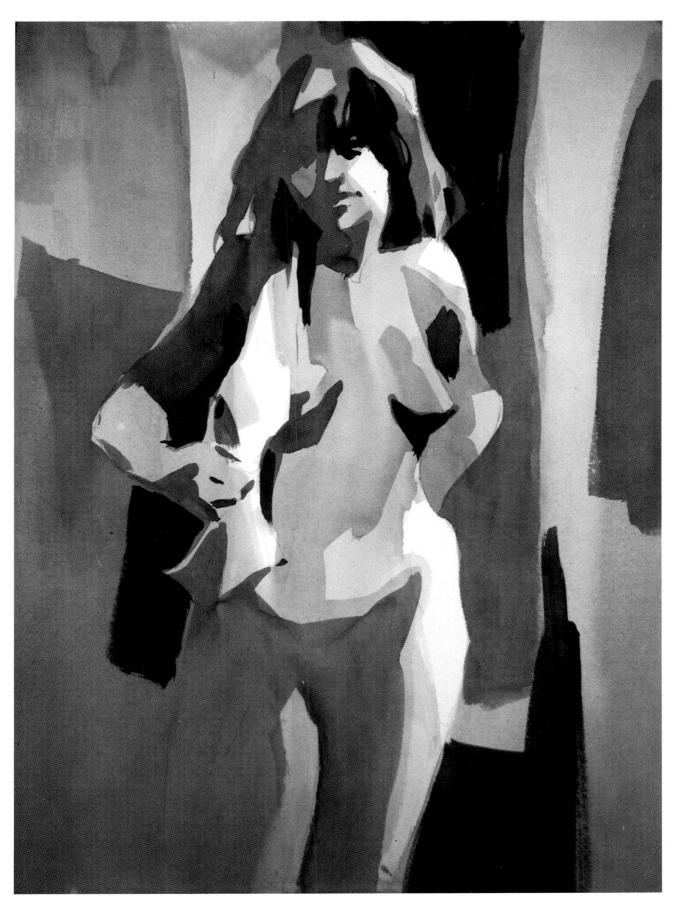

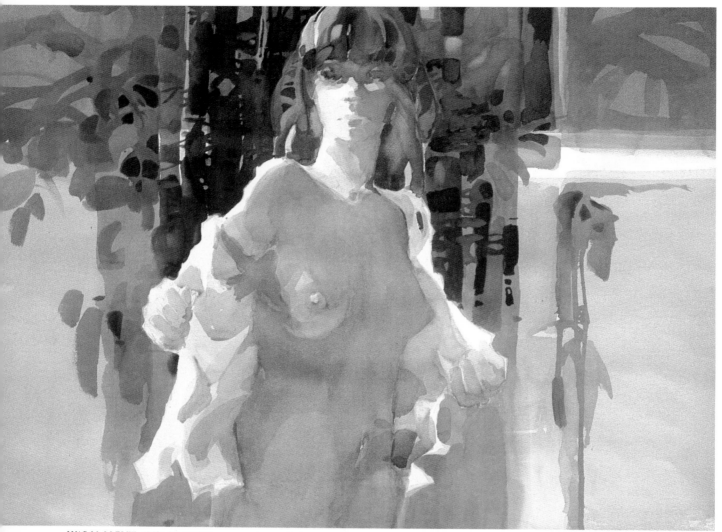

WARM LIGHT AND BAMBOO, watercolor on Arches 140 lb. cold-press paper, 22" x 30" (55.9 x 76.2 cm).

It seems to me that most artists who assume they are poor colorists need to increase their value concern. In the above painting, the question wasn't so much what color to choose, as what value or strength of color to choose.

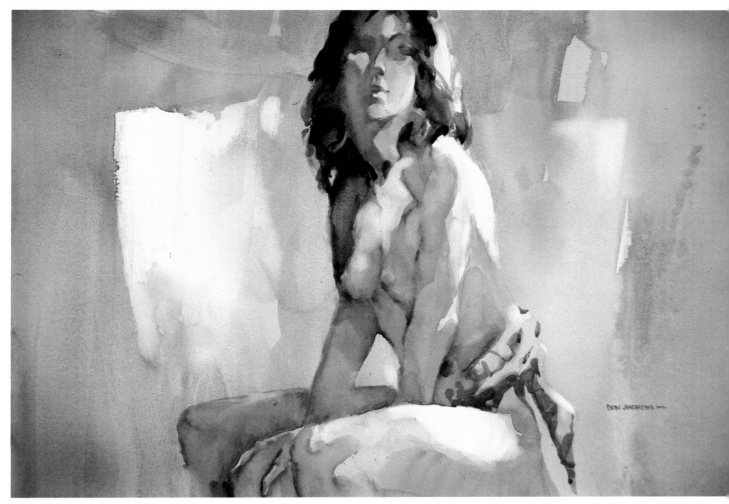

TAI, watercolor on Arches 140 lb. cold-press paper, 22" x 30" (55.9 x 76.2 cm).

The saved white paper on the model's hair, shoulder, and background, pitted against the powerful dark values in the shadows of her hair, produces the special accents in this painting. Yet these accents become special only when the majority of the painting is developed around a range of not-so-noticeable middle values.

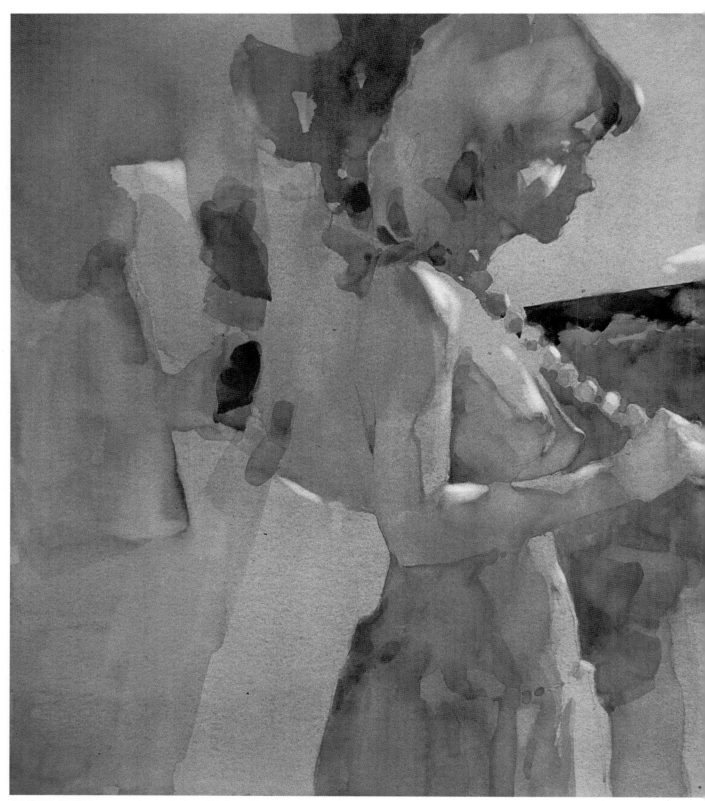

LINDA'S PEARLS, watercolor on Arches 140 lb. cold-press paper, 22" x 30" (55.9 x 76.2 cm).

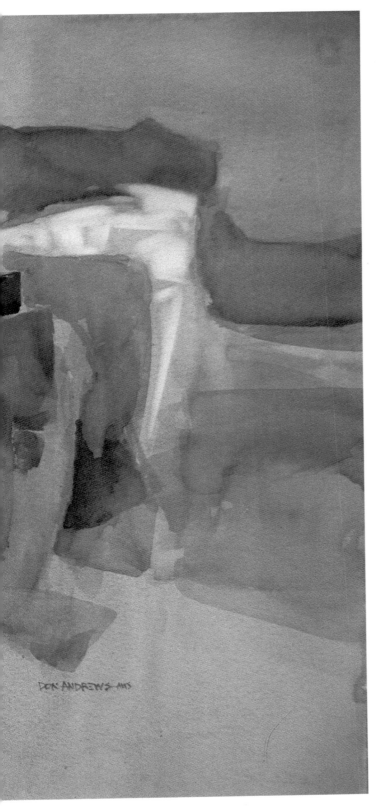

I received many compli-
ments on the color in this
painting, yet my concern as I
worked on it was to develop
as many stages on the value
scale as possible between the
extremes of light and dark.
The value goal, in fact, plays a
major role in generating the
success for which color re-
ceives the credit.

ACCENTS OF LIGHT AND DARK

By controlling the value development in a painting, the artist can develop special accents or emphasis with the placement and amount of lights and darks. The idea is that the eye will be drawn to the area of the greatest value contrast and that the dominant value will be common, and thus less noticeable. The value in the minority will be special and thus more visually interesting. Simply put, when the majority of the painting is developed in a value range of light and middle values, the light- and middle-value areas will be common. If a minimal amount of dark value is established within the painting, the dark value will be unique and therefore more attractive to the eye. Likewise, when a painting is established in middle and dark values, with a limited amount of saved light, the light area will demand the most attention.

When the majority of the painting is developed in middle and dark values, they become common or less demanding to the eye. The light value is purposely kept in the minority, which makes it unique; therefore, it attracts the greatest amount of attention.

Now we'll reverse the value arrangement and allow the middle and light values to be in the majority of the painting; now they become visual common characters. Here, I allow the dark to be kept in the minority of the painting, making it unique and therefore more visually noticeable.

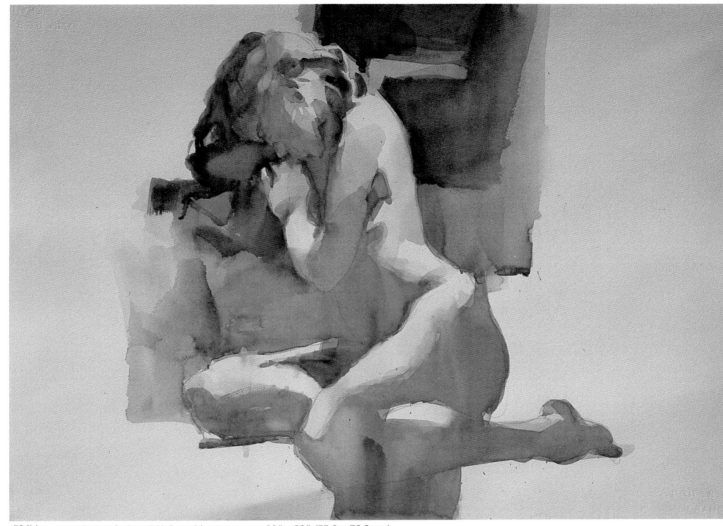

ERIN, watercolor on Arches 140 lb. cold-press paper, 22" x 30" (55.9 x 76.2 cm).

Because I allowed the majority of the page to be developed in light to middle values, the dark shapes became the accents in this painting. Since our eye is attracted to the areas of the greatest value contrast, we continually move from one dark value to the next, while the light to middle values are reduced to a supporting role.

By reversing the value plan, I've created a completely different painting, although the pose remains the same. Here, the majority of the page is developed in a middle-to-dark value statement, so the lights are accentuated. Again, our eye is drawn to the areas of the greatest value contrast, so the lights on the figure and background become special and the middle and dark values play a supporting role.

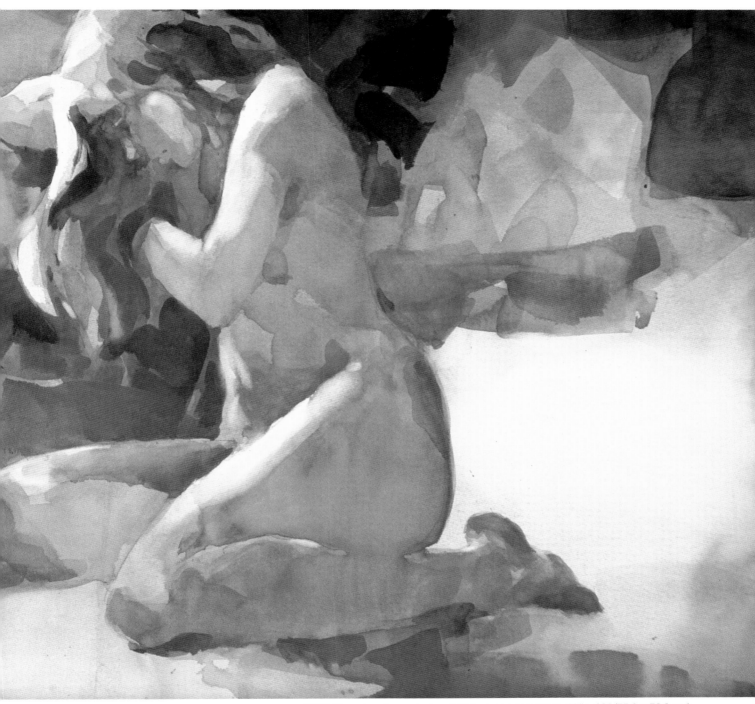

ERIN II, watercolor on Arches 140 lb. cold-press paper, 22" x 30" (55.9 x 76.2 cm).

TURNING ON THE LIGHT

The medium of watercolor is unique in that the highest value, or white, in a watercolor painting is actually the white of the paper. The white paper can take on a special quality of light when the artist saves a small amount of white paper and reduces the values of colors around it to contrasting middle and dark values.

A repeated theme in many of my paintings, and a real goal to strive for in watercolor, is to capture a small amount of white paper so that it appears to be bathed in glowing light.

Obviously, in order to make white paper special, we have to limit the amount of it we save in the painting. The idea employed again is contrast. As stated in our discussion on value, the more emphatically we drop the value around the saved whites, the more the white will be enhanced.

We see this theory in action with headlights on a car. They are dramatically light at night, when contrast is high, and unnoticeable in daylight, when contrast is low. Simply put, the key to turning on the luminous quality of light that white paper can take on in a watercolor is to drop the value in the majority of the painting to a range of middle and dark values.

To gain a better understanding of how the white paper can be enhanced to indicate light, I first make a drawing on my paper, and using a photograph as a reference, I decide where the light might best be displayed. Once this decision is made, I make a puddle of a light-middle-value color (I'll limit myself to neutral colors here so we can more easily think in terms of value). I begin by reducing all of the form to a single light wash, except for the areas of white paper I want to enhance. In effect, I begin by eliminating all competition of the saved white.

Once the first wash has had a chance to dry, I cut back into the planes of the face with a middle-value wash to create more value contrast between the majority of the shapes on the face and the saved white shapes.

Once the majority of the face has been established with a middle-value wash, I develop some areas of dark value. I place some darks next to the saved white on the model's face to emphasize the value contrast between the saved white and all other values on the page. Now compare the light on the model's face in this stage to the white on the model's face in the first stage.

SAVING THE WHITES

For the demonstration on light, I first decide on the pose and then adjust the spotlight so that most of the figure is in shadow and the light only hits it in a few places.

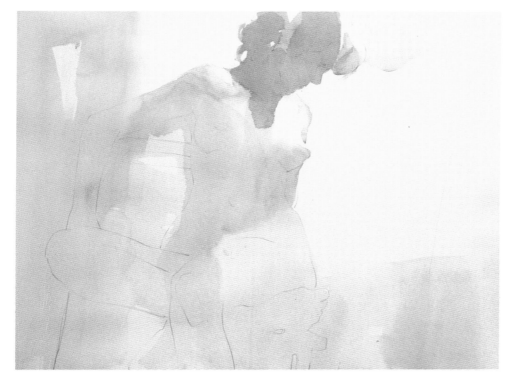

After making a drawing on the watercolor paper, I decide to push the color temperature of this painting to the warm side of my color palette. I begin my first wash with a light value of cerulean blue and follow with cobalt violet, knowing that I am about to overpower these cool washes with a more powerful mixture of contrasting warm colors. I am saving a few more whites in this beginning stage than I know I will need at the completion of the painting, but I am not sure yet which whites will be saved. It's much easier to eliminate the white paper gradually than to try to recapture it once it has been painted over.

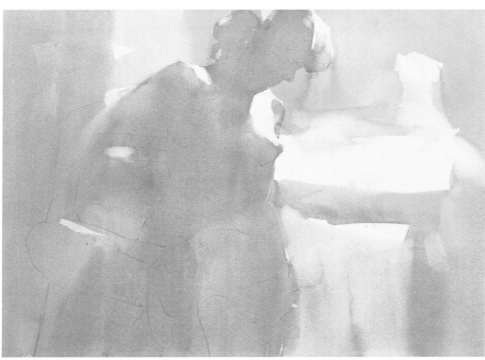

Rather than wait for the cool wash to dry, I jump in immediately with an overpowering value of warm pigment. I am still using light values, but I am adding more pigment to the light washes so that there will be an obvious value drop from the untouched white paper I have saved. I cut away a few more remaining whites until the only white paper left is that on the top of the model's head, her shoulder, and two or three areas in the background. At this point, I feel that one or two of the background whites might work well along with the whites on the figure, but I'm not sure which should be saved and which should be eliminated. I'll save them all until I get a better idea of which ones work best. At this point, I let the painting dry.

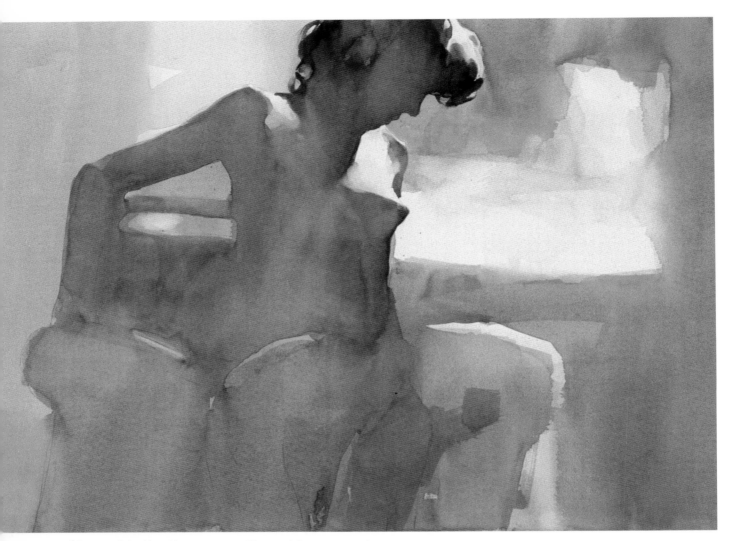

After much looking, I have decided to cut away most of the white paper in the lower middle section of the painting and to begin dropping down the value of some of the surrounding shapes as well. I feel the figure can now benefit from more definition, and I start by strongly darkening the value in the model's hair, this will be useful as a contrasting dark next to the saved whites on the top of her hair and on her shoulder. Immediately, these two saved whites become more emphatic. The urge now is to jump in and start throwing darks down everywhere! But I fight the urge and stop here to let the painting dry again.

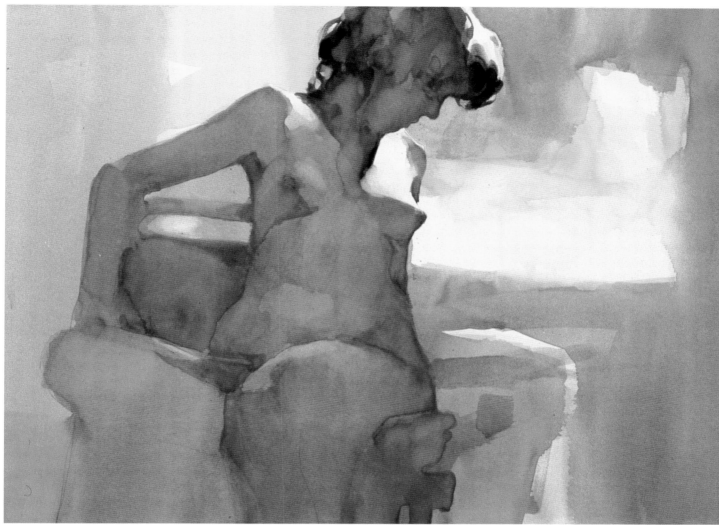

In the next phase, I work back into my main character (the figure), as I feel more anatomical explanation is needed. However, I am careful not to start explaining every square inch equally. I am trying to visually explain the necessities that make the figure believable, but equally important, I try to leave some of the figure lost as well as found. For instance, I just hint at the knee and leg in the bottom left and allow the shape to be mostly washed out rather than well defined. As I add more strength into a range of middle values in both the figure and the background, I begin to be aware of the white paper that now becomes glowing light on the model's shoulder and hair, and also of the saved background whites. There does seem to be a problem with the shapes and light in the background area in the lower middle portion of the painting, just beside the model's hip. The shapes are poorly structured, and the glowing light of white paper seems to call for more attention than the area needs. Again I stop to allow the painting to dry, and I make a mental plan of action in order to bring the painting to a successful completion.

I eliminate the problems of both the competitive light and the busy shapes in the bottom middle of the painting by painting out both problems with a simple dark middle value. Again, each time some of the light of the white paper is eliminated, the remaining saved whites become that much more emphatic. I now add a few dark middle values and dark shapes in the background, as I feel it needs a few hints of form, and more importantly, I want to continue to develop contrast in value between my saved lights and all other areas. Once again, the more I drop down the value in the majority of the painting, the more the few areas of saved light are turned on. I am now satisfied with the impact of the glowing lights on the figure's shoulder and hair and of the reflected light in the middle background. At this point, I call the painting finished. To gain a better idea of how much importance the white paper has taken on without being touched, compare the white paper on the figure's shoulder and hair in the finished painting to the same area of white paper in phase one.

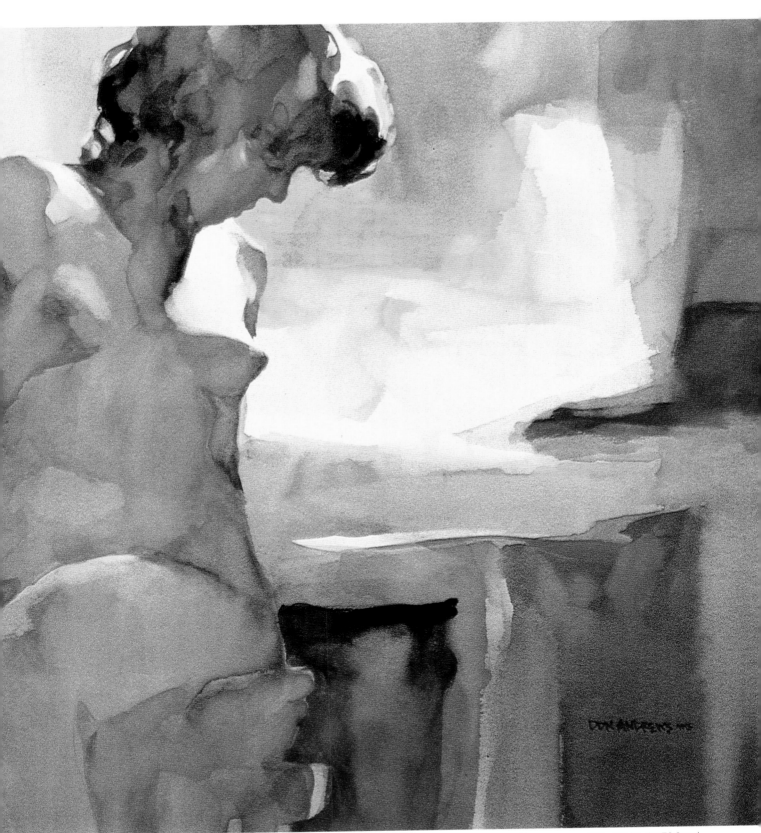

MORNING LIGHT, watercolor on Arches 140 lb. cold-press paper, 22″ x 30″ (55.9 x 76.2 cm).

CREATING CONTRAST
WITH WHITE PAPER

Though these three paintings were done at different times in my past and are of different models and background, the goal in all three paintings was basically the same: to enhance or turn on the sparkle of white paper so that it captures the essence of glowing light. Notice that though the color themes in the paintings may vary, the majority of the value in all three paintings is basically a range of middle to dark value; creating a great deal of visual contrast between the majority of the pigment and the saved white paper.

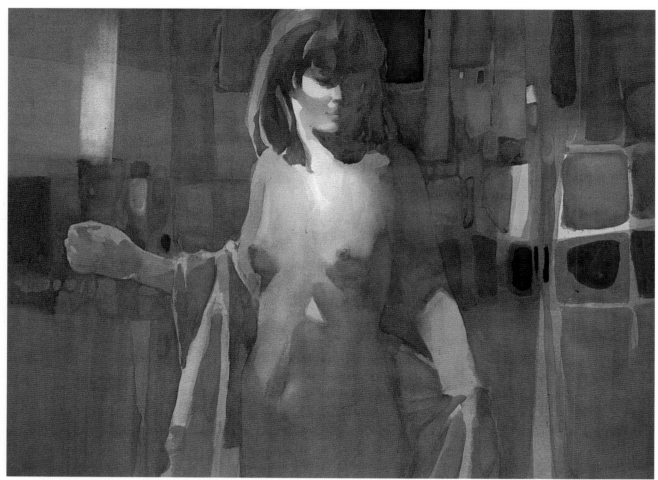

MELISSA, watercolor on Arches 140 lb. cold-press paper, 22" x 30" (55.9 x 76.2 cm).

Deciding where the lights will be established and where they will be eliminated is a personal decision and unique in every painting. After much looking, a large square shape of light on the far right of the background was eliminated, and a rectangular light in the upper left was created.

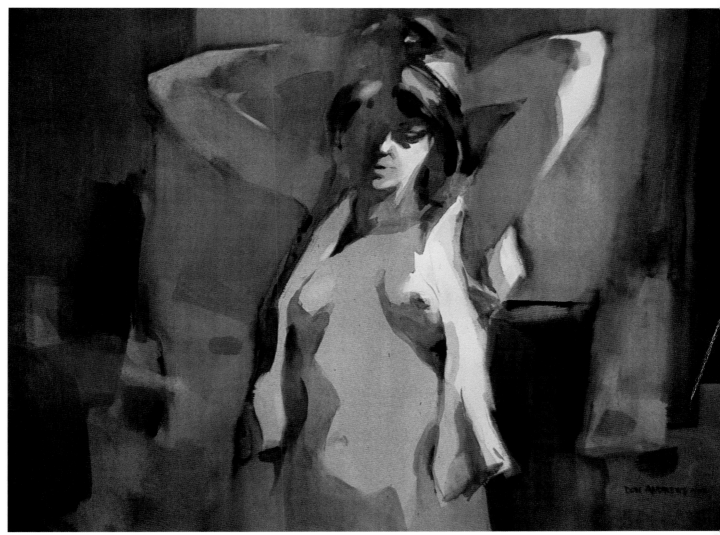

RENE, watercolor on Arches 140 lb. cold-press paper, 22" x 30" (55.9 x 76.2 cm).

By developing large contrasting areas of middle and dark value, a dramatic statement about light can be produced.

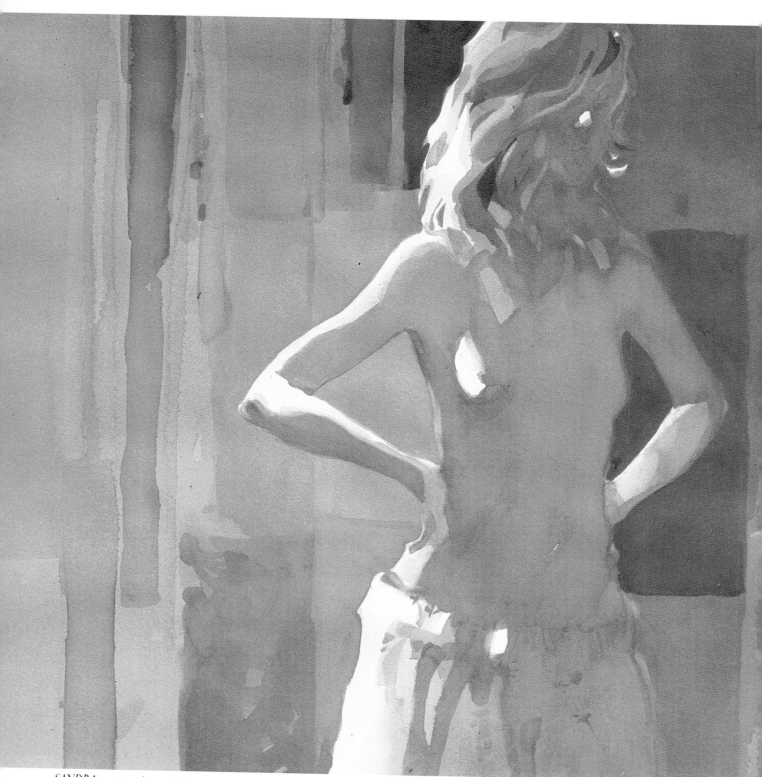

SANDRA, watercolor on Arches 140 lb. cold-press paper, 22" x 30" (55.9 x 76.2 cm).

The secret to turning on the glow of light is to eliminate most of it. Though in reality a good bit more light was actually found on the figure, I tried to continually cut away or push back most areas of light so that the few remaining lights I intentionally saved were enhanced.

CREATIVITY

Many nonpainters have the misconception when viewing a work of art that the artist actually sees the finished painting in his or her mind before beginning to work, that the artist merely copies down on paper an image in the mind's eye.

In reality, this is rarely the case. Though we artists might well have some feeling as to the direction of the outcome of a painting, we seldom have the security of knowing all the answers to how the final painting will develop in advance.

Creative painting seems to develop from a searching attitude, a trial-and-error arrangement of color, shapes, and values on the page. When I begin a new painting, my attitude is not one of control, but a kind of surrender, ready to react to the invitations of my taste and feelings.

To better explain, let's say that in the middle of a particular painting session, I notice a warm yellow light on the model's shoulder and I'd like to show it off. The first thing that comes to mind is to place a cool middle dark shape just behind the shoulder to enhance the warm light by contrast. If I were to verbalize my feelings during this painting session, it might sound like this:

"First I put down a cool middle dark shape of ultramarine blue just behind the shoulder. I step back and analyze: Does that work? Well, yes . . . but it's not quite right. Let's add a touch of Prussian blue to darken it. No, that's too dark, so I lighten the pigment with water. Now the value is better, but it appears too cool. So I add a hint of vermilion to neutralize it. . . . Is that better? Yes, but now I feel I need some of this coolish neutral color echoed somewhere in the painting to create balance and make the neutral blue belong. Well, where should it go? . . . I'm not sure, but I feel it might work over here. Yes, that balances on the page better, but now I feel I need. . . . " And so the painting continues to evolve as I work, trusting my feelings, experience, and taste to direct me.

During a painting session, we usually get some mental feedback or feeling about what shapes or colors might be needed to enhance the painting. But only after we put these ideas down on the surface of the paper can we make a judgment as to how well the color or shape actually works. Only when I have the color or shape on the paper can I truly see it or evaluate its effectiveness.

In the above example, I started out feeling that a shape of middle-dark ultramarine blue was what I needed to excite an area, but I had to put the pigment down on the paper before I could know if it truly was a workable answer. Many times I find my first impulses are fairly close, but an adjustment or refinement of the color or shape is usually needed. In this case, I added some vermilion to the ultramarine blue to adjust the color to my liking.

Of course, many times after I have put down a color or shape, I realize that it doesn't work well after all. I find these negative responses aid in the direction of the painting, just as the more positive ones do. After all, discovering what doesn't work leads us closer to what does work.

In the search for creativity, we first look to our own feelings for direction. Next, we put down the color, value, or shape and step back to judge whether or not it works well, rather than having all the answers in mind before ever touching the white paper.

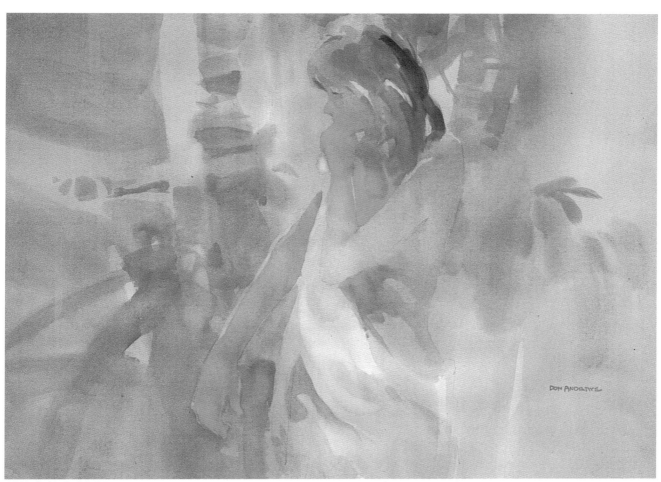

TAMARA'S GARDEN, watercolor on Arches 140 lb. cold-press paper, 22" x 30" (55.9 x 76.2 cm).

The subject matter for this painting was fairly complicated. The problem wasn't so much how to paint figure, fabrics, and foliage, but rather how to make these separate characters appear to belong together. By allowing the pigment to flow through the lines of the various parts of the subject matter, I established a relationship between them. The pigment that describes the hair flows into the face, face into arm, arm into fabric, and fabric into foliage.

CREATIVE PRE-PLANNING

It is generally a good idea to have some mental direction in mind before we begin the painting. Pre-painting thoughts can be sketched out to help us understand what shapes or organization of shapes might work best with a particular pose. The plan might be a stated decision about color temperature or value strength. ("In this painting, I want to show off the lights.")

These mental directions help focus our attention on valid goals other than just explaining the subject. Though we should expect to alter or adjust our direction as the painting develops, an open-ended plan or direction generally makes the outcome of the painting more decisive.

When I first began painting, I was told that watercolor is "90 percent planning and 10 percent painting." Though this might be a good rule for the first year of painting, I soon began to realize that I was painting out the best parts of my paintings in order to follow the predetermined plan.

The purpose of the advance plan for a watercolor is to give us some idea of the direction we want the painting to take. The plan can help us get actively involved in the start of a painting; however, we should follow the plan only as long as it is working well. When we see better opportunities for the development of the painting while we're working, we should follow our feelings and leave the plan behind. It is when we allow the predetermined plan to over-shadow our feelings and we are unwilling to leave it, that the plan becomes a block to creative involvement.

How often have you been in the middle of a painting when a special color or shape arrangement presented itself? When this happens, our senses come to the forefront, our feelings take over, our individual tastes begin to give us signals. We begin to leave our plan or preconceived thoughts of how the painting was supposed to develop and begin to watch the paper in front of us. We alter and invent shapes, colors, and values as the painting evolves. We allow ourselves the freedom to watch the paper and trust our feelings to guide us through the painting. In doing so, we are opening the door to creativity. Painting with this attitude, we can certainly expect to fail more often than we would with the security of a predetermined plan, but it is often through this trial-and-error searching that our best paintings happen.

My motivation for this painting was not to accurately record the image of the figure on my paper but to search for a new and exciting arrangement of colors and shapes on the page. When we change our goals or reasons to paint, our paintings reflect this change in direction. There is certainly nothing wrong with painting the figure as it truly exists in nature, but be aware that there are other valid objectives worthy of our attention as well.

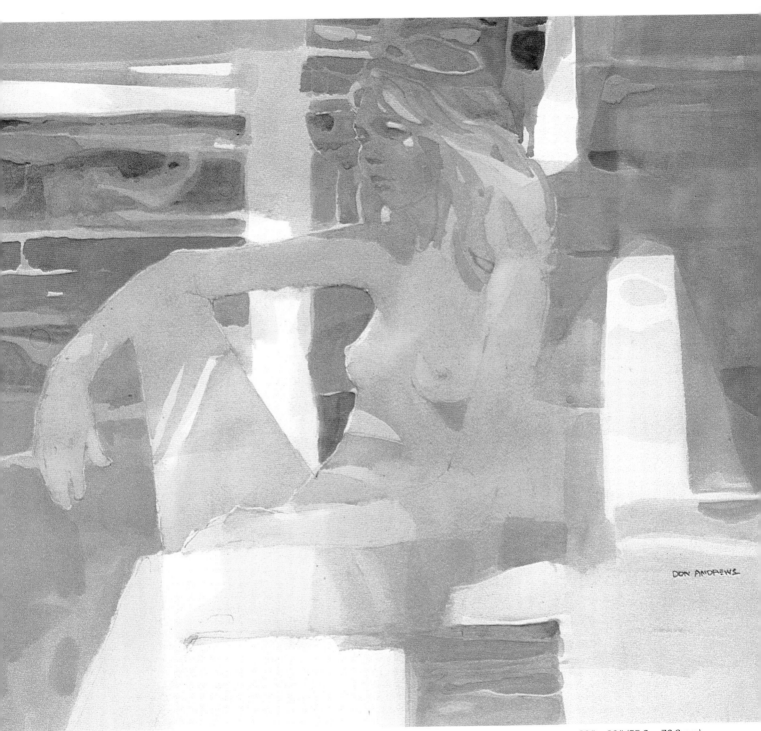

LINDA'S COLORS, watercolor on Arches 140 lb. cold-press paper, 22" x 30" (55.9 x 76.2 cm).

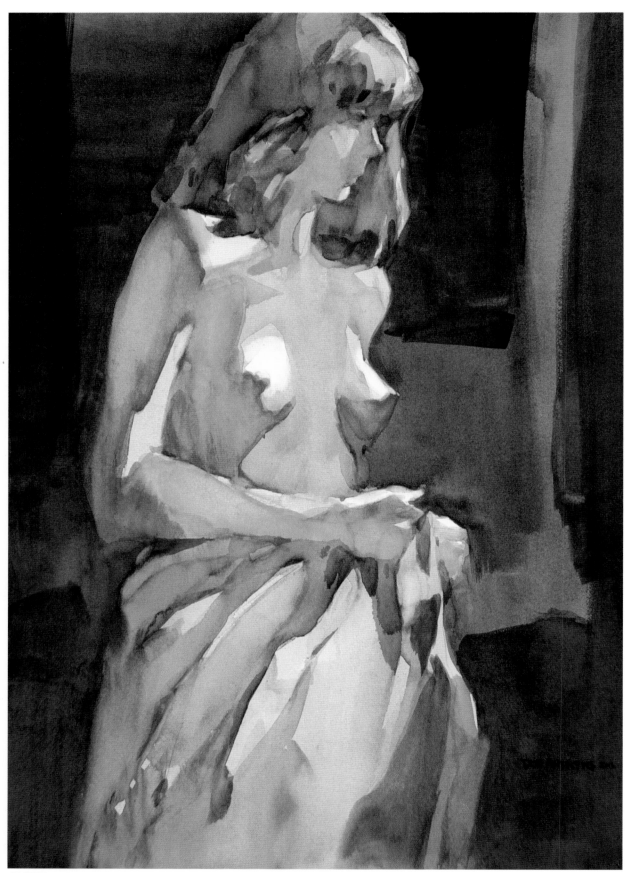

VICKIE, watercolor on Arches 140 lb. cold-press paper, 22" x 30" (55.9 x 76.2 cm).

The search for creativity involves stepping out into areas in which we are unsure: trying new color combinations and shape arrangements.

When we, through habit, continually reach back to the same paint combinations we have used successfully in the past, our paintings become predictable. On the other hand, when we consciously search for new answers to painting questions involving color and shape organization, we continually gain new insight into what the possibilities of exciting painting can be. We widen our vocabulary and stretch our imagination.

Many people assume that creativity is something we are either born with or have to do without, but in my experience, creativity is more like a muscle that must be exercised in order to be developed. A painter might spend a great deal of time and effort selecting just the right color combinations to coordinate his wardrobe or tastefully decorate his home, yet go into the studio and begin a new painting with the same predictable colors he has used so many times before. This same painter might go from one success to another simply by reworking the same idea again and again. But while he won't fail much, he won't grow much either.

I once knew a painter who made a great deal of money painting wildlife scenes of ducks flying in over the water. When I had seen several of his paintings, I began to notice that in each one there were the same ducks, the same trees, the same clouds, etc., but in each painting, the artist had merely rearranged the formation of the ducks or moved the trees from one place to another. I suppose the only creative challenge open to him whenever he began a new painting was, "Where will I put the ducks this time?"

One of the biggest blocks to creative expression is that we feel unsure of the outcome of our paintings when we are exploring unfamiliar territory. But isn't that what creativity is? We *should* be surprised by what we discover. When we are trying new color mixtures or pushing shapes around in new designs on the page, we won't have the security of knowing the painting will succeed every time. However, by using the principles of color and design that were discussed in earlier chapters, we will have some guidelines to hold on to as we search. We can say, "I don't know in advance how all the shapes in the painting will be arranged, but I will look for some large, simple mass to play against the small and interesting shapes." Or we can think, "I don't know exactly what colors will be used to excite the painting, but I will look for some cool accents to offset the mostly warm colors or some darks to show off the lights."

If your painting seems to explain the subject of the figure well enough, but there doesn't seem to be a sense of excitement or creativity in your work, perhaps you are putting too much emphasis on depicting the subject and not enough on directing your energy toward other possible painting goals. While we should look at subject matter as one aspect of painting, it is certainly not the only reason to paint.

Have you ever heard a friend comment, while viewing one of your recent paintings, "Well I sure like the paintings you used to do." I think this backhanded compliment is a good indication that we are growing beyond the "pretty picture" stage most of our family and friends would like us to stay in. Though the person making the comment is really trying to tell you to go back to the same old worn-out things of the past, I think it's really a good sign that you are looking for new directions, taking new chances, and opening the door to creativity.

When we depend less on a preconceived plan and allow ourselves to "watch the page" and trust our feelings and taste to direct us through the painting, the door to creative expression opens. In this painting, the background shapes and values were arranged and rearranged many times until I finally discovered this striking arrangement.

WHO'S THE BOSS?

It seems that we, as painters, are always looking for ways to gain more control of the medium or subject matter in order to force our work into an acceptable result or finish. Unfortunately, it also seems that we are generally at our worst when we are trying to force ourselves to perform.

A few years ago, a prominent show deadline sneaked up on me. I had had some success in the show in past years and wanted to send in a slide of my best effort. As I only had a week or two before the slide deadline, I went into the studio the next morning to paint specifically for the show. Needless to say, the paintings I attempted for the next few days were miserable—totally controlled, overworked, and over-explained. Finally, I got mad enough at myself to say, "Forget this—I just won't worry about the show this year. I'll just relax and enjoy painting and see what develops." Thank goodness better things began to happen. How did I do in the show that year? Never mind.

It just makes sense that the painting is going to reflect the attitude of the artist. If the artist is tight, trying to stay in control and forcing the painting to follow a preset course, it is understandable that the finished work will mirror this attitude. I'm not so sure I'd like my paintings to be described as tight, controlled, or forced. We seldom admire a painting by saying, "Gosh, isn't that painting controlled!" Explaining subject matter with control has its place in painting, but we must realize that this technical explanation can also be a barrier that must be broken if we are to paint on a creative level.

The first stage of this painting was a large abstract wash that covered the entire page. I wanted to express the beauty and versatility of the medium with granulated warm and cool brushstrokes and allow my immediate needs on the page to direct my actions. I hoped to find excitement in the ever-changing wash, but I did not know when or where it would present itself to me. Once the abstract wash had dried, I painted a simple linkage of the shadow pattern of the figure over the wash and lifted a few lights where I felt they would be beneficial.

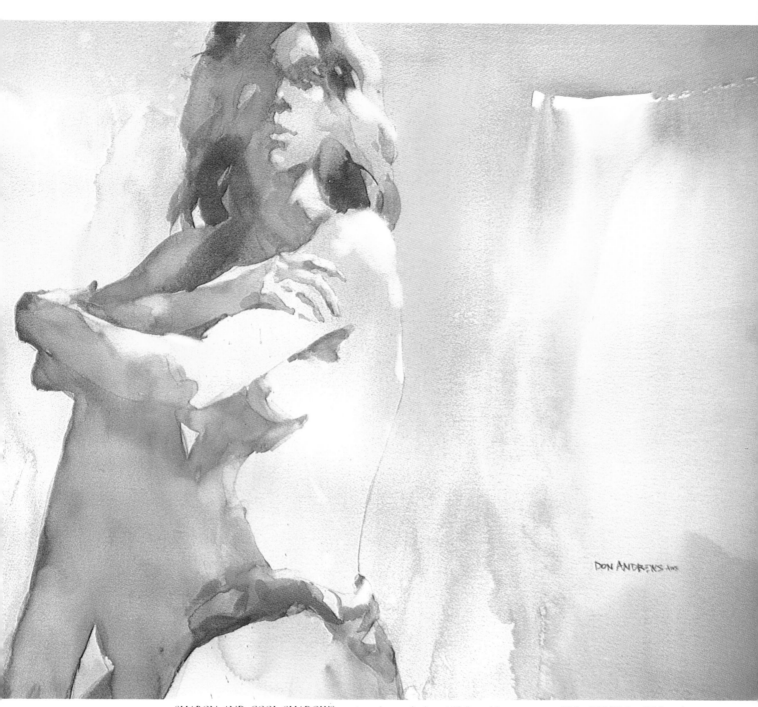

SHARON AND COOL SHADOWS, watercolor on Arches 140 lb. cold-press paper, 22″ x 30″ (55.9 x 76.2 cm).

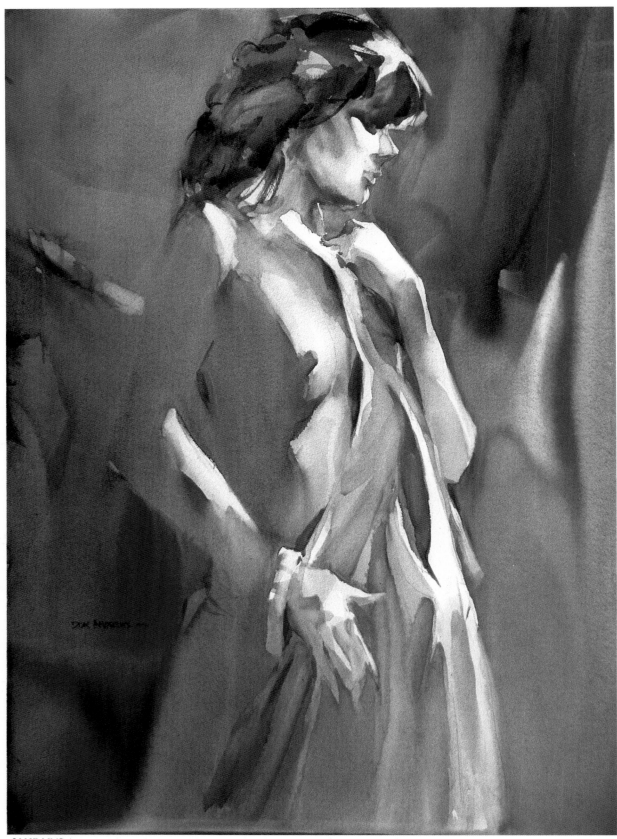

BLUE LINDA, watercolor on Arches 140 lb. cold-press paper, 22" x 30" (55.9 x 76.2 cm).

I believe the most important element involved in creative painting isn't so much having creative ability as having a creative attitude. And nowhere is the artist's attitude about the subject more obvious than in a figure class or a workshop. Almost without exception, the most exciting drawings and paintings are done in the quick two-minute gesture sessions. We have our cheaper paper out and we're not expecting to paint anything frameable, so we jump in, take chances, and watch the page.

Later in the day, the pose is slowed down to an hour or two. The good paper comes out and our attitude changes. "Now it's time to do a good painting," so we tighten up to gain control, and in the process, our drawings change from loose and interpretational to tight and detailed. Again, the finished painting reflects this attitude change. How is it that we can do such wonderful things in two or three minutes and such rigid, predictable work in an hour or two? When we slow down the pose and get out the good paper, we don't lose our abilities, we simply change our attitude.

There have been a lot of intriguing discussions in art circles recently concerning the two hemispheres of the brain and how they relate to painting. While there are many artists who have explored this mental process and its effects on painting in far more detail than I have, it does seem evident that we tend to operate in general and paint in particular using one hemisphere of the brain or the other. The right hemisphere controls our creativity and feelings. The left hemisphere controls our thinking and analysis. Though we can't consciously change hemispheres of the brain while painting, we can allow ourselves to move into the right side, the creative hemisphere, by giving ourselves goals (reasons to paint) that are less analytical and more creative or discovery-oriented.

Let's compare the artist's goals and mental attitude in the warm-up session to the goals and mental attitude in the two-hour pose. In the quick warm-up session, the goals are to discover excitement in line quality, color, and value, as well as to develop interesting shapes and patterns. The artist hints at the reality of the figure but doesn't feel bound by it. He or she expects to interpret and discover rather than technically explain the subject. He is less judgmental and expects some failure as well as success.

In a two-hour posing session, on the other hand, the artist's goals (and therefore hemisphere) change to a more analytical attitude. In effect, he tries to draw and paint the subject without making any errors. The result is that he concentrates on technical correctness more than on paint quality. The artist tries to be in control of the medium and to visually show what he knows about the medium and the subject. Put simply, the artist is looking not to create but to control.

You must be aware of your goals before you begin to paint. Rather than force the painting to develop in a predetermined direction with you as "the all-controlling master" and the painting as "the slave," allow it to have some say in its own development. React to what happens as the painting develops, and give yourself room to explore. Set valid goals other than technical correctness to search for when you begin a painting. Paint quality, light, exciting color, and shape organization are valid reasons to begin work, and they invite the artist into a more personal realm of creative painting.

Rather than having a predetermined concept of how the background would develop in this painting, I began by allowing the shadow pattern of the figure to flow out into the background with large granular washes, and allowed my immediate needs to guide my actions.

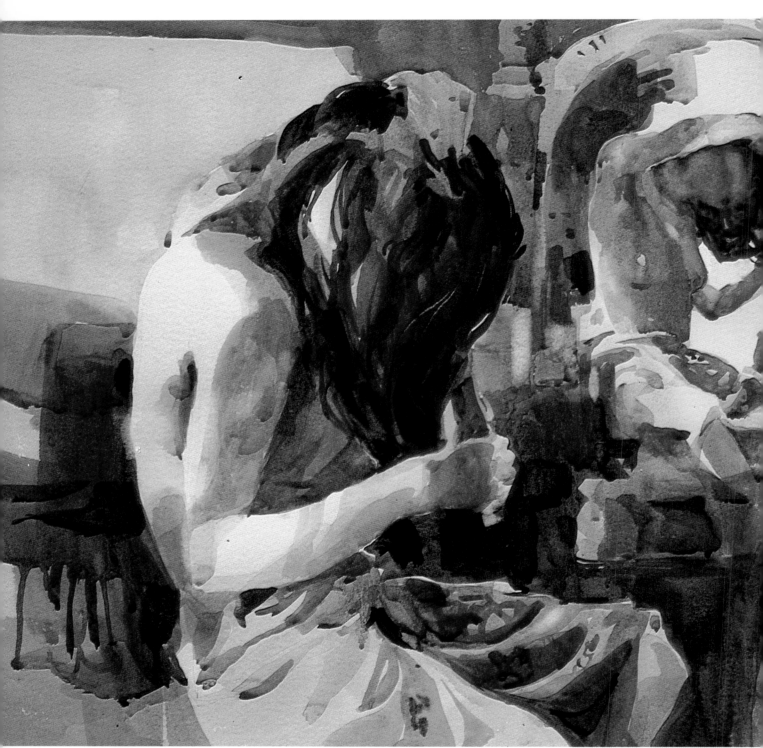

REFLECTIONS, watercolor on Arches 140 lb. cold-press paper, 22" x 30" (55.9 x 76.2 cm).

This painting was done several years ago, and it remains one of my favorites. I can remember stepping back to take a look at the drawing of the girl combing her hair in the mirror and admitting to myself that my limited abilities were no match for this ambitious subject. After all, it's hard enough to paint a figure without the added challenge of reversing the image on paper and making both figures appear to be doing the same thing. Having accepted impending failure, I decided that since the drawing was already on the page, I might as well go ahead and have a good time and see what happened.

In the dictionary, the word "failure" is described as the opposite of success. In painting, however, it seems that failure leads to success, and without a certain amount of failure, we can never achieve success.

As painters, we should continually be challenging ourselves. It seems that as soon as we get "good enough," we've stopped looking for new answers. The painter who goes from one success to another is usually just reworking yesterday's painting over and over again. In the search for new answers to painting questions, we should expect to fail—and often. Failure comes from searching in areas we are not familiar with, and through this searching we are learning.

As artists, we should develop an attitude about failure much like that Babe Ruth must have had about hitting a baseball. Babe Ruth is known as "The Home Run King," "The Sultan of Swat." In his most celebrated season, he hit just over 60 home runs. We might consider, however, that in that same season, the Babe went to the plate over 400 times, and the majority of those times he struck out. In fact, Babe Ruth struck out more than any other player on his team. He met failure many more times than his teammates. He must have realized that he could have played it a little safer at the plate and reached first base more often, but reaching first base wasn't the Babe's goal.

On a given Saturday at the ballpark he might strike out several times, but he understood that these failures were only temporary setbacks that would ultimately lead to his desired goal. No matter how many times he struck out in past innings, each trip to the plate was a new opportunity for success. He took "the full swing" and went for broke on every pitch.

We artists should look at our painting experience in much the same way. We can't expect to be successful every time we pick up our brushes, but every painting session should bring us a new opportunity for success. We need to look at our previous failures as temporary setbacks that will ultimately lead to our desired goal and not just strive to get to "first base" with a painting. Remember, our potential as artists can only be achieved if we take "the full swing."

WORKING WITH A MODEL

Before starting a figure painting session, it is a good idea to give the model some understanding of what your goals and needs are as a painter and how he or she can best help you. Remember, your model is a human being, not a department store mannequin. Invite her to be a part of the pose selection as much as possible. Ask her to use her imagination and make suggestions; let her know that she is a participating member of the class and that her input is both needed and encouraged.

Be aware that the difficulty of a particular pose must be compatible with the length of time the model will be asked to hold the pose. The off-balance, exaggerated action poses are fine for the quick two-minute gesture sessions but would be impossible to maintain for any length of time. In general terms, the model might use her muscles to hold the faster poses but rely on her bones for the longer sessions. No matter how comfortable a specific pose may appear, it can become tedious when held for an extended period of time.

I advise the model that if she gets a muscle cramp or her wrist or leg falls asleep during the course of a twenty-five-minute posing session, it's all right to interrupt the pose for a moment to get the blood flowing again. Most times we painters become so involved in our work that we don't even notice this quick intermission.

I generally divide my painting sessions into twenty-five-minute intervals with a five-minute model break in between. I have found that using a kitchen timer that can be set to ring when the time is up frees both the model and me from the bother of watching the clock. For a warm-up gesture session at the beginning of class, I set the timer on twenty-five minutes and ask the model to change from one pose to the next when she feels that two minutes have elapsed, giving the class roughly twelve or thirteen different poses during the twenty-five-minute period. I warn the model not to wait for me to ask her to change poses, as I may get involved with my painting or get into a discussion and can easily turn a two-minute pose into a twenty-five minute sitting.

Let the model know your expectations as an artist. Suggest that in the gesture painting session, variety is the name of the game. Instruct her to vary the direction she faces continually and to give a variety of standing, seated, and lying poses and positions. Each pose should change the mood as well as the stance. Of course, feel free to make suggestions to the model, but allow her to interpret your suggestions as well, and when she hits an especially pleasing pose, be sure to let her know. Remember, the more she understands about what you, the artist, are looking for in a pose, the more she will be able to carry it out.

For the longer poses, a little more instruction on pose selection is usually needed. Try to give hints rather than being too specific. The more the model understands the direction of your thinking concerning the pose, the more she will be able to help you. Look for a pose that will be comfortable as well as pleasing from an artist's point of view. Try to verbalize your impressions about the pose as much as possible.

Modeling is both physically and creatively challenging work. Let the model know her efforts are noticed and appreciated.

Be concerned with your model's comfort and needs. It's a good idea to have a portable heater available as well as a chair, throw pillows, and various draperies around the model's stand. Always ask before taking photos of a pose; some models don't mind being photographed, but some mind very much. And remember that extra compensation should be offered if photos are taken. In fact, if you plan to take photographs, it's a good idea to get permission and make financial arrangements with the model beforehand. Be considerate of your model's privacy. Lock the studio doors or place a sign on the door to alert unsuspecting intruders.

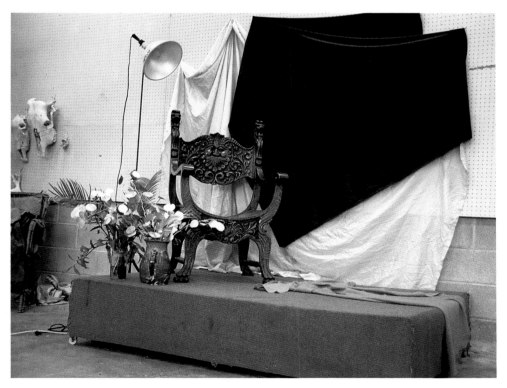

The model stand at my local art association is fairly simple, but a very workable one. The podium raises the model up above floor level so he or she can be seen from across the room or from the back row of easels. It is carpeted for added comfort. A Peg-Board or wooden backdrop behind the podium is used to display a variety of draperies and other articles; it can be adjusted easily. There are always chairs, flowers, fabrics, pottery, and other props around the studio that may be introduced to give flavor to the pose. It's a good idea to have an electrical outlet near the model stand for the spotlight and portable heater.

WHAT'S A GOOD POSE?

I am often asked by students and models, "What is a good pose?" or, "What do you look for in a pose?" My answer is fairly simple and somewhat evasive: I look for poses that are natural, as if the model isn't posing at all or is unaware that she is being painted or photographed. I tell the model to sit in a chair or on the podium as she might sit when she is watching television or lying on the floor or in bed reading a book. She should give the impression that she is alone and comfortable, as if she is getting ready for her day, admiring herself in the mirror—not the "cheesecake" pose that implies she is posing for a photograph or for someone. Simply put, the best poses look as if the model isn't posing at all.

The best poses for me seem to be the ones that appear as if the model isn't posing at all or is unaware that she is being painted or photographed. This particular painting was done from a photograph I took of my wife while she was taking a break from a posing session.

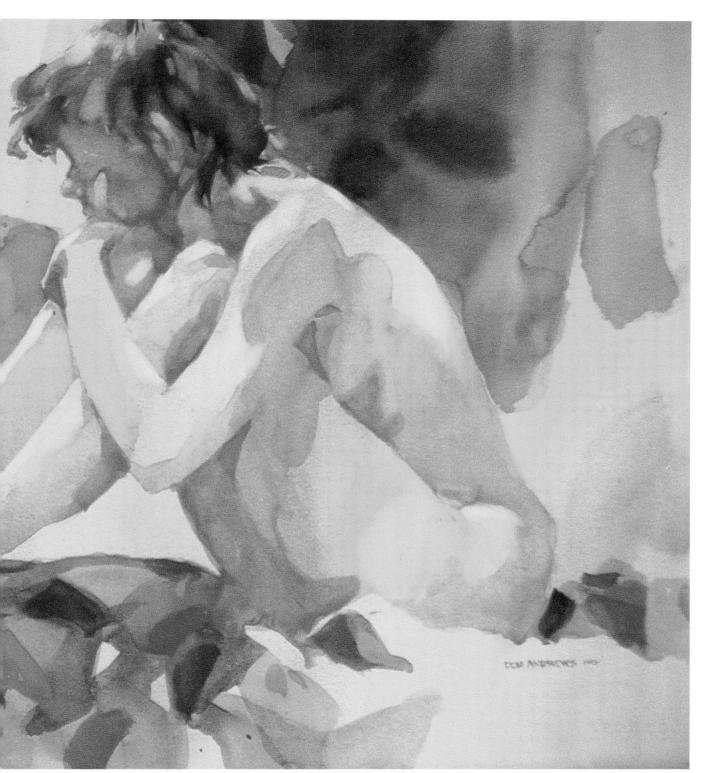

LINDA'S QUILT, watercolor on Arches 140 lb. cold-press paper, 22" x 30" (55.9 x 76.2 cm).

UNBALANCED POSES

I find I am constantly discovering new and exciting pose possibilities. On the other hand, I am also continually going back to the old photographs or asking models to do classic or old familiar poses that I have painted many times. By changing the goal (reason to paint), I can take a new approach to painting a pose I've done before. We don't have to paint the same pose the same way every time. I give myself new reasons to paint rather than always changing the pose.

I find that poses that are unevenly balanced give life and action to the painting (A). We never sit rigidly in a chair or stand at attention. We generally put our weight on one leg and brace one hip with our hand. Also, when the model is unevenly balanced, I find I am able to balance the painting by adding characters or shapes to the background to offset or counterbalance the shapes of the pose (B). This unifies the figure and the background.

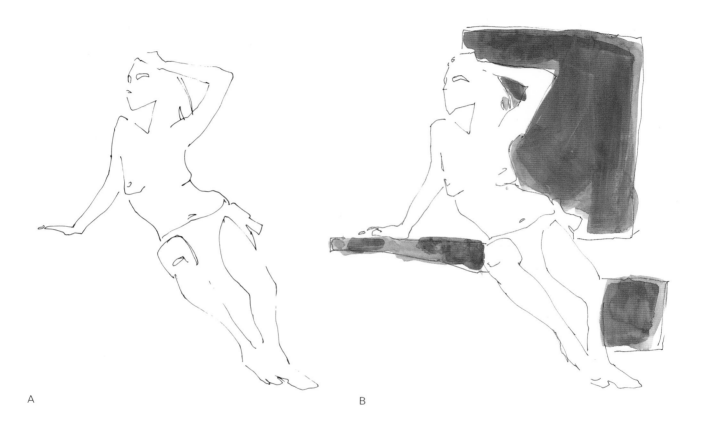

A

B

WORKING FROM PHOTOGRAPHS

I often hear artists comment that they can't do any figure work because they don't have access to a model. Certainly it would be ideal if we could have a model sit for us on a daily basis; however, in most situations that just isn't practical. I have found painting from photographs to be a workable alternative to working from a live model. Of course, painting from photographs has some disadvantages, but there are many positive aspects as well.

Keep in mind that when working from a photograph (even more than from a live model), the artist sees a great deal of information that will have to be reorganized, understated, or eliminated.

The camera is a tool that gives us information, but it is our job as artists to use this information in a creative way. Unlike the human eye, which focuses in on one area and allows the surrounding areas to become more and more out of focus, the camera's eye will bring the model and her immediate surroundings into focus with equal clarity from head to toe. Every aspect of the model will be visually explained in great detail. Even more than when we work directly from a live model, when we work from a photograph we often have a tendency to over-explain.

Be aware of this danger when painting from a photograph, and expect to compensate by eliminating much of the information the photograph provides. Think of the photo image as a store of facts from which you must pick and choose the minimum amount of information necessary to explain the subject and play down, push back, or eliminate the rest.

There are, however, many advantages to working from a photograph. First, the camera is able to capture many action, off-balance, or standing poses that the model would be unable to hold for any length of time. For instance, let's say you'd like to do a finished painting of a standing model tying a ribbon in her hair just behind her head. This pose (as seen at right) would be impossible for the model to hold for the length of time necessary to do a full-sheet painting. However, the camera can capture this graceful but strenuous pose and allow the artist as many hours as needed to comfortably complete the painting.

How many times have we been in the middle of a critical part of our painting in a figure class with a live model posing when the bell rings for the break? We beg the model to sit an extra minute, and we hurriedly throw on the paint, being more concerned with the time than with paint quality. About the time we finish, the other class members are coming back to their places, ready to resume work, and the poor model still hasn't gotten a rest. No matter how considerate the model may be, you know what she must be thinking.

With a photograph, we are able to work at our own pace, stop when necessary to let the painting dry, or get a cup of coffee and look awhile. The painting session may last several hours or just a few minutes between breaks. Also, there is never any problem getting the model back into exactly the same pose after the break.

I'm not the kind of painter who wakes up at 3:00 A.M. filled with inspiration and ready to paint, but I know painters who claim to be. Regardless of what your painting schedule is or when you like to paint—morning, noon, or night—when you use a photograph, the model is always available. In short, photographs free the artist to work without the concerns of time or access to a model.

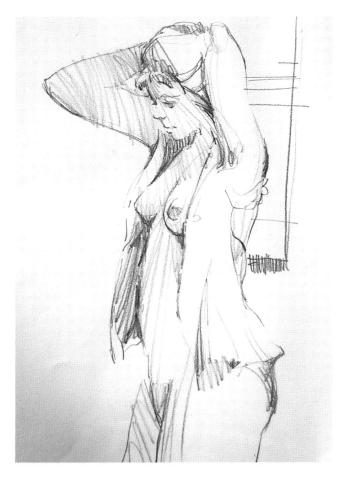

PHOTOGRAPHING THE MODEL

To photograph the model, you will need a good 35mm camera and film made for working indoors with limited lighting (ASA 400 or higher). This will eliminate the need for a flash, which would destroy the linkage produced by a spotlight. Use a spotlight to create linkage on the model as discussed in the chapter on linkage.

Rather than spending a great deal of time working out the perfect pose with the model, have her change poses every two minutes or so in a variety of positions. As she is posing, move around her until you find a pleasing angle, then take a picture. A particular pose can also offer a variety of good angles, so be sure to move around the model rather than always taking shots from just one spot. Take several shots from different angles as the model continues to change poses until you have taken a few rolls of film. Don't expect each shot to be workable as a prospect for a painting, but if you get eight or ten photos from a thirty-six-exposure roll that offer good possibilities for a painting, your time was well spent. When my prints are processed, and I have picked out the photos I feel would make good paintings, I usually have 5″ x 7″ (12.7 x 17.8 cm) enlargements made to work from.

It is easy to add some hints of background possibilities by setting up impromptu props around or behind the model as she poses. Pillows, fabrics, plants, and pottery are just a few possibilities. I want to stress again that the camera will record these background elements with great detail and importance. Props can add to or create a mood but should not be painted with the same importance the camera gives them. They are only suggestions or painting possibilities. Props often will need to be rearranged, simplified, or subdued. Don't allow them to remain as important as they usually appear in the photograph. "If in doubt, leave it out."

Try using black-and-white film as well as color film for the photo session. Black-and-white film gives excellent value information and invites you to be more creative in your color choices rather than just copying the local color in the photograph. Since your camera shop has little demand for black-and-white print development these days, your black-and-white film will probably have to be sent to the factory to be processed. This means it can take a week or so to receive your black-and-white prints, as opposed to the one-hour processing of color film.

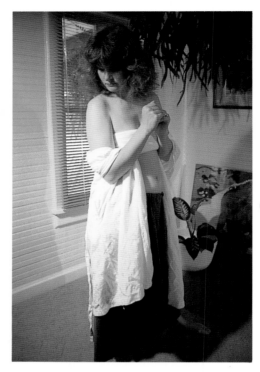

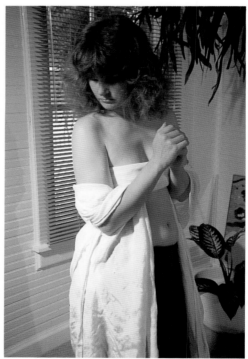

When the model strikes a pose during a photo session, rather than always capturing the entire figure and her surroundings (as seen in the top photograph), I try to place the image of the figure in the camera's viewfinder as I think it might best be placed on the watercolor paper (bottom photograph). This brings the model up as close as possible so that I can get a better view of the structure, lights and shadows, and various edge qualities.

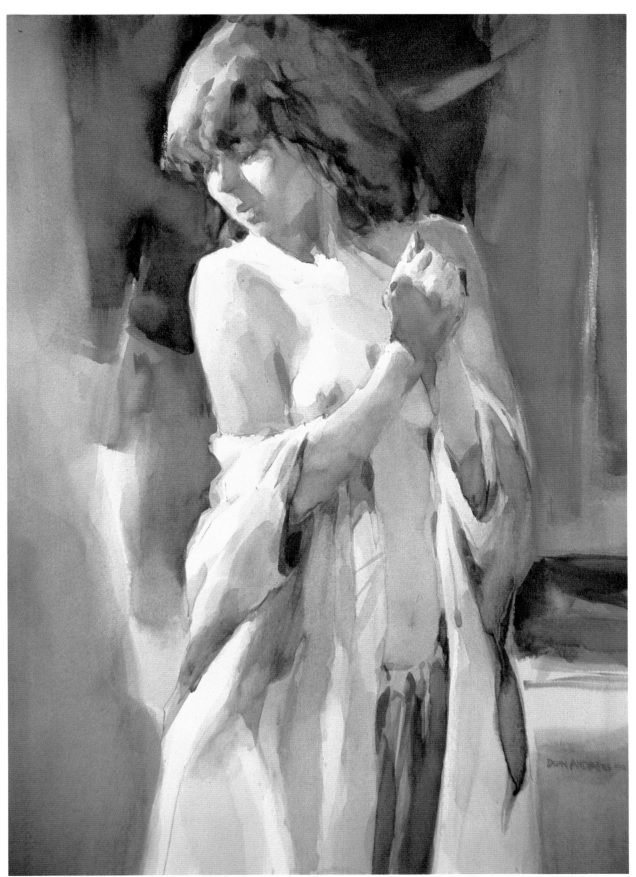

ELAINE, watercolor on Arches 140 lb. cold-press paper, 22" x 30" (55.9 x 76.2 cm).

INDEX

Edited by Candace Raney
Designed by Areta Buk
Graphic production by Ellen Greene